IMAGES
of America

WHITTIER

IMAGES
of America
WHITTIER

Mike Garabedian and Rebecca Ruud

ARCADIA
PUBLISHING

Published by Arcadia Publishing
Charleston, South Carolina

Printed in the United States of America

Library of Congress Control Number: 2015943285

For all general information, please contact Arcadia Publishing:
Telephone 843-853-2070
Fax 843-853-0044
E-mail sales@arcadiapublishing.com
For customer service and orders:
Toll-Free 1-888-313-2665

Visit us on the Internet at www.arcadiapublishing.com

With sincere gratitude, this book is dedicated to Ruth Webster Lynch (August 1, 1951–April 8, 2015), longtime Whittier resident, reference librarian for the City of Whittier, and local historian; without her initial help and encouragement, this book would not exist.

CONTENTS

ACKNOWLEDGMENTS

All books are the product of a community effort. This publication would not have been possible without the generous support and encouragement of many Whittier community members, but we want to name a few whose contributions to the work were particularly exceptional.

We want to thank Hannah Colvin, of the Whittier Museum, and Erin Fletcher Singley, of the Whittier Public Library, for assistance with photograph duplication, reference help, and solving more than a few mysteries, but also for all the hard work these professionals do to share Whittier's history with researchers and patrons. Thanks also to Whittier Historical Society president Tracy Wittman and Whittier Public Library director Paymenah Maghsoudi for being gracious and helpful hosts and providing us access to their collections.

We want to thank filmmaker and historian John Garside, a shepherd through the early history of Whittier, whose knowledge of the city and excellent Whittier documentaries (all available for free online) informed many of our decisions. Thanks to Steven Otto for helping us spread the word about the book and providing feedback about the images we discovered; thanks, too, to the many members of the Facebook page he administers ("Whittier, California - Our Hometown") for providing invaluable information about more recent Whittier history and helping to answer many of our questions about people and places that are no longer here. And thanks to Kim Wicker and Judy Jansen for providing insights about and access to photographs of Whittier in the mid-20th century and the years leading up to its centennial.

We want to thank our students—in particular Gawen Grunloh, Alejandra Gaeta, and Priscilla Gutierrez—for their assistance, and our colleagues, the staff of Wardman Library at Whittier College—Cindy Bessler, Shezad Bruce, Sonia Chaidez, Anne Cong-Huyen, Laurel Crump, Joe Dmohowski, Kathy Filatreau, Chris Greenwood, Mary Garside, John Jackson, Steve Musser, and Nick Velkavrh—for their support, advice, patience, and friendship while we were writing this book. Thanks also to our families and non-work friends for their continued encouragement.

Finally, we want to thank our editors at Arcadia Publishing—Henry Clougherty, Lily Watkins, Alyssa Jones, and Sara Miller—for their wisdom, keeping us on track, and helping us establish deadlines (and for their understanding when we sometimes missed those deadlines).

For the purposes of attribution, the courtesy lines at the ends of captions accompanying images from the collections of the Whittier Public Library are abbreviated as "WPL"; those from the collections of the Whittier Historical Society at the Whittier Museum are abbreviated as "WM"; and those from the Whittier College archives are abbreviated as "WC."

INTRODUCTION

Hiking in the canyons or up the slopes of the Whittier Hills still gives a sense of what this land was like before Quakers founded their "city of dreams" here in the late 19th century. Oak and sycamore trees flourish alongside seasonal creeks and on the hillsides, while wild mustard transforms the place into a shockingly vibrant yellow meadowland in rainier springs. On a clear day, the sun glints off the Pacific Ocean, 20 miles away, while to the north, the San Gabriel Mountains rise majestically from the valley floor. On the southeast-facing slopes of the hills, where the Quakers settled, ocean breezes keep the land cooler than the flatlands below, while the hills themselves act as a kind of "wall" to prevent severe winter frosts—a climatic feature appreciated by Whittier's first citrus farmers and touted by the city's earliest boosters.

The first people to settle in the area that would become Whittier were the Tongva, Native Americans later known by the Europeanized name *Gabrieleño* after Mission San Gabriel Arcángel, which was originally located in today's Whittier Narrows on a small tributary of the San Gabriel River. The Tongva moved into the Los Angeles basin from Southern Nevada some 3,000 years before they encountered Spanish explorers in the region in the 1540s, when their population may have reached 10,000. Before European contact, the Tongva had developed a society comprising hundreds of independent villages scattered across the basin and generally close to permanent sources of water like the Los Angeles, Santa Ana, and San Gabriel Rivers. Those who settled near the San Gabriel River in what would become Whittier called this land and their village "Sejatngna."

What happened to Sejatngna and the Tongva near Whittier is a story no less tragic for its familiarity. Following the arrival of Spanish missionaries, led by Fr. Junípero Serra Ferrer, and the founding of the San Gabriel mission in 1771, the several-millennia-old lifestyle of the Native Americans began to disintegrate. Forced conversions, subjugation, compulsory relocation to the mission complex, and the institution of slave labor decimated the Tongvan population; European diseases killed still more. Mission priests made subjugated Tongvans plant European grains, New World vegetables, and the first citrus trees in California near the mission complex. There, fertile soil and clement weather, combined with a steady supply of water from the river, made the area a center of agricultural production. However, in 1776, a flood wiped out the mission crops and the complex itself, compelling the Spanish colonists and their Tongvan subjects to relocate some five miles upriver to the mission's current location in present-day San Gabriel. By the start of the 19th century, a few small, scattered, and ramshackle Tongvan encampments still existed along the San Gabriel River south of the old mission site, but Sejatngna and Tongvan society were effectively gone forever.

In 1784, Gov. Pedro Fages granted former Spanish soldier and Gaspar de Portola expedition member José Manuel Nieto provisional use of the 300,000 acres between the Santa Ana and Los Angeles Rivers from the San Gabriel mission down to the Pacific Ocean—the largest Spanish land grant in California. However, San Gabriel mission priests contested the award, suggesting it encroached upon property that was rightly theirs. After a protracted legal battle, Gov. Diego de Borica reduced Rancho Los Nietos to about half its size, and the Rancho Paso de Bartolo—a new grant comprising present-day Montebello, Pico Rivera, and Whittier—again became mission property. After the secularization of the missions in 1835, the Mexican government awarded Rancho Paso de Bartolo to Juan Crispin Perez, a manager at the mission complex. Perez used the grant for its intended purpose—the cultivation of livestock—and grazed herds of cattle and sheep on the flatlands and hillsides of the area that would become Whittier.

Following Perez's death and the conclusion of the Mexican–American War in 1847, former Alta California governor Pío Pico began procuring parcels of the Rancho Paso de Bartolo from Perez's heirs, acquiring approximately 9,000 acres by 1852. That year, Pico built an adobe home

on the east bank of the San Gabriel River and called his estate El Ranchito ("little ranch"); it was separate from his much larger ranch, Santa Margarita y Las Flores, which comprised more than 130,000 acres of land in northern San Diego Country at present-day Camp Pendleton. Pico lived at El Ranchito—on land that would become west Whittier—for four decades. The former governor frequently opened his homestead to visitors, hosting fiestas, rodeos, and country dances. However, El Ranchito was also a working ranch where vaqueros grazed Pico's immense cattle herds on the mesas and plains east of the river and produced livestock to help meet the post–Gold Rush demand for beef. In Pico's later years, bad business dealings wiped out his fortune and land holdings, and in 1883, he lost Rancho Paso de Bartolo in what many historians describe as a real estate scam. Pico was evicted from the old adobe in 1892 and died penniless two years later.

Following the Mexican Cession of 1848, many land-grant holders, including Pico, sought to capitalize on the post–Gold Rush influx of Anglo immigrants to California by subdividing land into smaller townships (like "Picoville" in 1867) and selling parcels to private buyers. Moreover, free land between the ranchos became public property that the federal government began granting to Anglo immigrants via the Homestead Act of 1862. In 1868, German immigrant Jacob F. Gerkens purchased 160 acres on the southern slope of the Whittier Hills in just this way, paying $234 to the federal government, building the simple home that would become the Jonathan Bailey House, and turning the property into a working sheep ranch. By 1879, Gerkens had sold his property, called the "Mustard Ranch," to John Thomas, who, with other business associates, aggregated an additional 1,100 acres of adjacent land to establish the Thomas Ranch. Eight years later, the 1,259-acre ranch was offered for sale during the beginnings of a Southern California land boom. In May 1887, Aquila Pickering, Jonathan Bailey, Hervey Lindley, T.E. Newlin, and John Painter formed the Pickering Land and Water Company in order to purchase the ranch for $69,850 and establish a Quaker colony in Southern California; the company subdivided the ranchland and offered parcels for sale on May 19. Not long after, the nascent settlement was named after the 19th century's most famous abolitionist Quaker poet, John Greenleaf Whittier.

The following chapters cover the first 100 years of Whittier, beginning just before the arrival of the Quakers and ending in its centennial year of 1987. This is by no means a comprehensive history; however, we hope to have captured the most salient and definitive aspects of Whittier's singular past and presented these aspects in a sensible and mostly chronological narrative. Readers who want to know more about Whittier's history should consult some of the published sources available at the Whittier Museum and the Whittier Public Library and examine their impressive collections of photographs and documents, more and more of which are being made accessible online every day.

One

BEFORE THE QUAKERS
THE LATE 19TH CENTURY

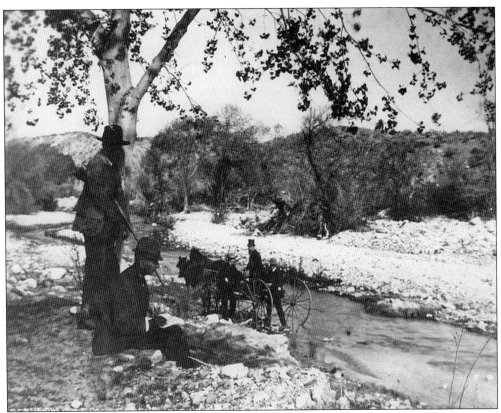

Anglo-American settlers traverse the Little V Creek near the San Gabriel River around 1875. Before the end of the 19th century, the settlement near what would become Whittier was dictated by where inhabitants—Native Americans, Spanish Catholic missionaries, then Mexican and American ranchers—could obtain water for drinking and irrigation. (Los Angeles Public Library.)

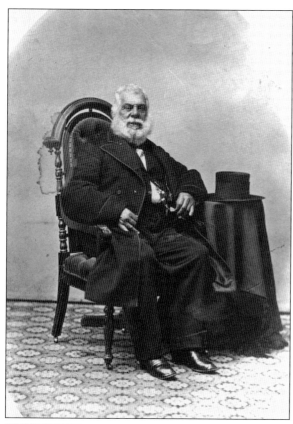

Born in 1801 at the San Gabriel mission, Pío de Jesús Pico was the last governor of Mexican Alta California. A wealthy man by midcentury, Pico bought the Rancho Paso de Bartolo, an 8,900-acre Mexican land grant, in 1850; it included half of the area that would become Whittier. In 1852, he built a home on the ranch on the east bank of the San Gabriel River, where he lived for 40 years. (WM.)

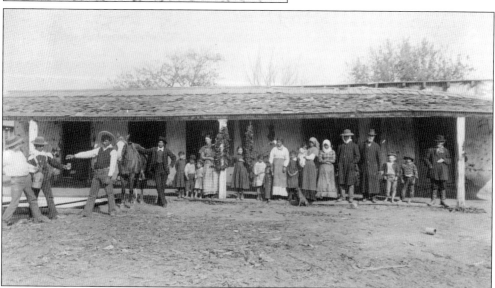

Pico dubbed his estate "El Ranchito" and built a chapel, saloon, and guesthouses. Regular fiestas, rodeos, and dances rendered the working ranch a *Californio* time capsule, even as white settlers poured into the region in the late 1800s. Unfortunately, Pico fell victim to bad business dealings and a real estate scam. In 1892, he lost El Ranchito and was evicted from his adobe homestead; he died in poverty two years later. (WM.)

Pío de Jesús Pico's neighbor and friend Harriet Williams Russell Strong, proprietress of the San Gabriel River-adjacent Ranchito del Fuerte, was among the first to suggest preserving Pico's old adobe homestead for posterity. Strong purchased and restored the property in 1909 and gifted the land to the State of California in 1917. In 1927, El Ranchito was designated one of California's first state historic parks. (WM.)

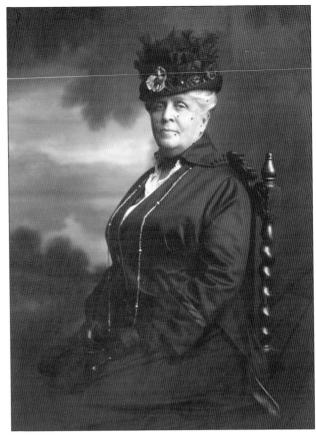

Widowed in 1883 at age 39, Strong immediately attended to running the Ranchito del Fuerte, planting walnut trees but also pampas grass, whose plumes she sold to European milliners, amassing a fortune. A National Women's Hall of Fame inductee, Strong was a community leader, philanthropist, composer, and pioneer in water conservation who was granted patents for new irrigation techniques. In her later years, she advocated for women's rights, education, and suffrage. (WPL.)

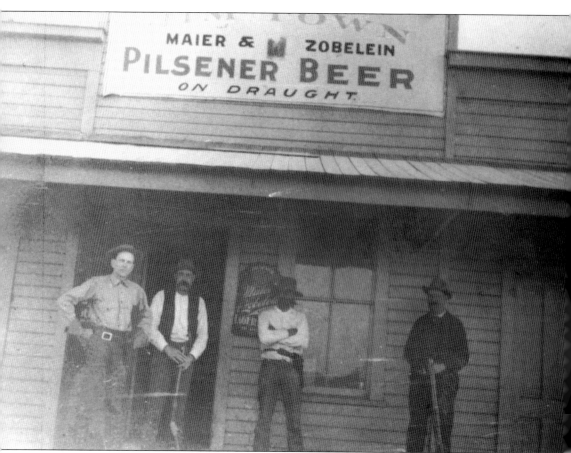

In 1867, Pío de Jesús Pico plotted the town of Picoville on El Ranchito land, which included a riverside camp of Tongva Indians and Mexican laborers. In 1892, saloonkeeper Jim Harvey purchased the property, which was bounded by Whittier and Beverly Boulevards, the San Gabriel River, and Whittier's western border. Many of the agricultural laborers who patronized Harvey's bar constructed a shantytown on Picoville's former streets. In the early 1900s, "Jim's Town" (later "Jimtown") remained "a rendezvous for bands of gypsies and undesirables" and "soakers," according to early Whittier historians B.F. Arnold and A.D. Clark. Disdainful of these neighbors and dedicated to preventing the ill effects of what John Greenleaf Whittier called "the evil of intemperance," Whittier's Quaker settlers outlawed saloons—even incinerating a makeshift tavern in 1888—and prohibited construction of drinking establishments within the town limits until 1940. (WM.)

Two

A QUAKER COLONY
1887–1898

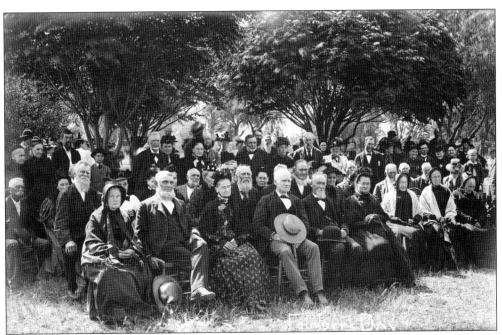

Begun in 1894, Whittier's Founders' Day picnics have always been held in Central Park. This photograph from one of the first picnics features some of Whittier's earliest Quaker settlers and founders in their characteristic plainclothes, including Henry Dorland, Nele Davis, and Whittier's first Quaker settlers, Rebecca and Jonathan Bailey, who are at far left in the first two seats of the front row. (W.E. Butler, WPL.)

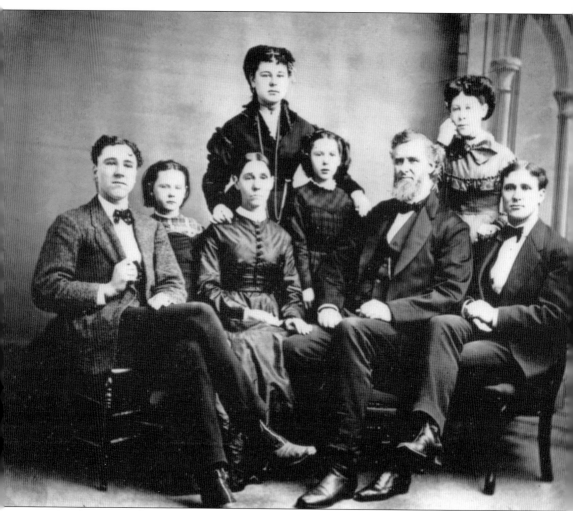

Aquila Pickering, pictured here with his first wife, Ruth Dorland, and their children, is generally regarded as the person most responsible for choosing the location for the Quaker colony that became Whittier. A Chicago-based Quaker businessman, Pickering and his second wife, Hannah, came to California in early 1887 to establish a faith-based community that would have a positive impact on a state where "the need of moral and Christian influence was everywhere apparent." Near the end of their search, in early spring, the Pickerings visited the John M. Thomas Ranch, a 1,300-acre tract for sale 15 miles southeast of Los Angeles. As Aquila later recalled, "From the first we were favorably impressed with this beautiful situation: the high ground sloping away from the Puente Hills from which we could see the whole valley reaching toward the south and west until our eyes rested upon the ocean, some eighteen miles away." (Barbara Rasmussen.)

Shortly after his arrival in Southern California, Aquila Pickering met with Quaker educator (and, later, Whittier College president) Thomas E. Newlin, who introduced him to other Quakers from Pasadena and Los Angeles interested in the colony proposal, as well as real estate agent Hervey Lindley (pictured). Lindley helped the Quakers organize the Pickering Land and Water Company in order to option the John M. Thomas Ranch and served as the group's first secretary-treasurer. (W.E. Butler, WPL.)

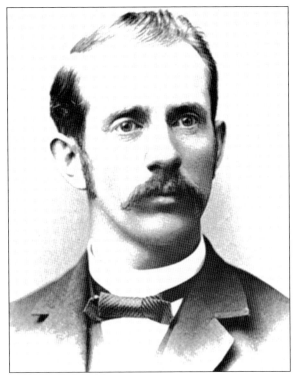

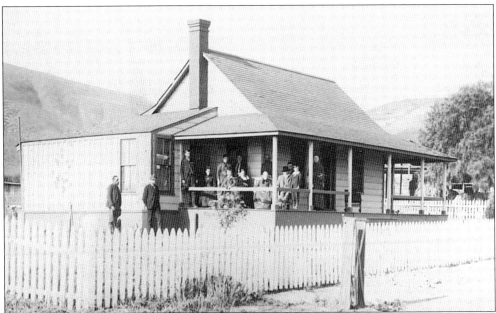

On April 8, 1887, the Pickering Land and Water Company board met at the ranch house on the Thomas tract and agreed to buy the land for $69,890 from then-owner J. Mill Boal, who had purchased the property from Thomas in August 1886 for $33,000. Representatives from the Pickering Land and Water Company signed the deed on May 11, 1887. The house (later called the Jonathan Bailey House) became the site for meetings of the company and, subsequently, a hub for religious, social, commercial, and civic meetings in Whittier's earliest days. (WPL.)

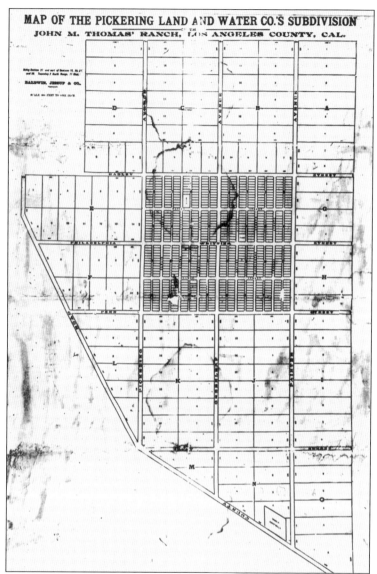

MAP OF THE PICKERING LAND AND WATER CO.'S SUBDIVISION
JOHN M. THOMAS' RANCH, LOS ANGELES COUNTY, CAL.

With Lindley's guidance, the Pickering Land and Water Company contracted with real estate and surveying firm Baldwin & Jessup to subdivide the ranch land, with 160 acres offered as town lots and the rest of the property broken into five- and ten-acre parcels sold at $100 an acre on the condition that buyers agreed to make $1,000 worth of improvements. In this map from mid-May 1887, the principal north-south avenues and east-west streets have already been designated, named after concepts and places dear to Quaker hearts (e.g., Friends, Penn, Philadelphia); the recently-named town-to-be (Greenleaf and Whittier); the board and members of the company (president Jonathan Bailey; vice president John Painter; Aquila Pickering; and secretary-treasurer Hervey Lindley's father, Milton); early residents John Bright and Mahlon Newlin; and an early investor in the colony, Washington Hadley. The founders' educational aspirations are also evident in the street just north of Penn, called "College" some six years before the construction of Whittier College's Founder's Hall. Expectations were exceeded on the very first day of sales; enthusiastic buyers crowded Lindley's Los Angeles office on the morning of May 19 and bought nearly 250 lots for a total of $34,000. (WM.)

While it is unclear whether Pasadena Quaker Elizabeth Grinnell or Los Angeles city treasurer M.D. Johnson proposed to name the town after celebrated Quaker poet John Greenleaf Whittier (pictured), the idea was enthusiastically approved at a May 1887 meeting of the Pickering Land and Water Company and the town so named by the summer of 1887. Although the founders invited Whittier to visit, the then-frail poet was never able to make the trip from Massachusetts. (WC.)

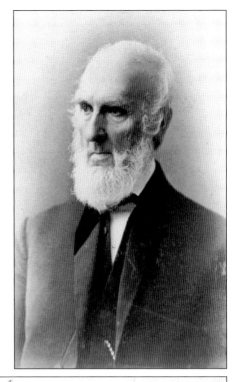

In this October 1887 letter, Whittier thanked Hervey Lindley for the "high compliment [of] giving [his] name to the new colony and city," noting, "I am glad to know that a settlement of Friends is established in the loveliest section of Southern California with a climate of unsurpassed healthfulness and a soil of marvelous fertility, where mountain, vale, and ocean combine to render it 'beautiful for situation.'" (WC.)

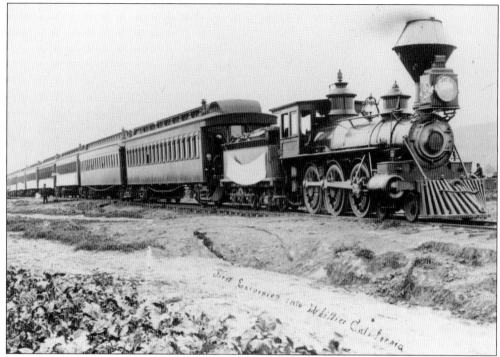

In July 1887, Quaker colonists embarked upon a two-week journey by train from the Midwest. Direct passenger service to Whittier was still several years off, so the pioneers disembarked at the closest depot, located some seven miles away in Norwalk. From there, they were transported to Whittier via wagon stage, as A.D. Clark recalled, "over the mesa, through the sand, and through the mustard that grew eight to 10 feet high." (WPL.)

Most Quaker colonists stayed in Norwalk or pitched tents while waiting for their land and houses to be gradually allotted and constructed. The home in the background and water spigot in front of Iowa-born Quaker John Chew's tent on Bright Avenue indicates that this is a post-1895 photograph, but the setup of early pioneers would have been much the same. (WM.)

Jonathan and Rebecca Bailey were living in Los Angeles and among the first Quakers to visit the Thomas Ranch in 1887; in May of that year, Jonathan was elected president of the Pickering Land and Water Company, and the Baileys became the first Quaker settlers in Whittier when they moved into the ranch house on the property. Jonathan served as an ambassador and guide to tourists, investors, and settlers who came to Whittier in the 1880s and 1890s, greeting new arrivals on horseback at the Norwalk station and, later, at the train depot on Philadelphia Street. As Virginia Mathony notes, in Whittier's earliest years, the Jonathan Bailey House "became the center for all business, social, and religious activity, as Jonathan directed the development of the new community." (Both, WM.)

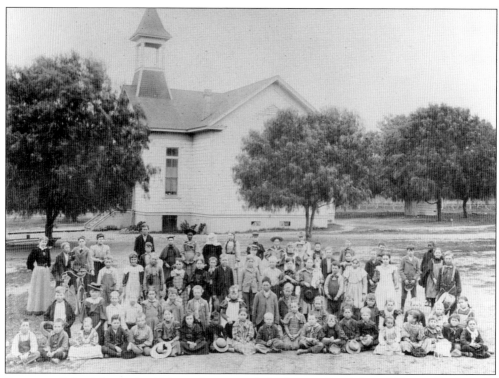

Evergreen School, located at Painter Avenue and the County Road (now Whittier Boulevard), was two years old when the Quakers arrived. It was the only primary school that served the huge district, which was bounded by the Puente Hills on the north, the west border of La Habra on the east, Los Nietos to the south, and the San Gabriel River on the west. Evergreen became part of the new Whittier District after the construction of Bailey Street School in 1889. (WPL.)

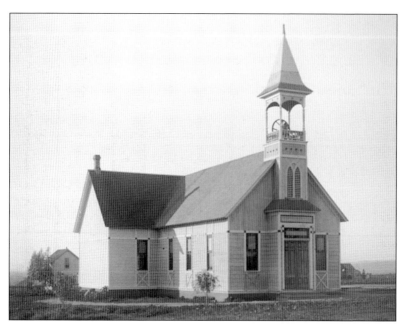

In 1887, the Pickering Land and Water Company built Friends Church, Whittier's first church (and the second building constructed in town), at the southwest corner of Comstock Avenue and what is now Wardman Street for $1,600. The inaugural service was held on August 14 that year. (W.E. Butler, WPL.)

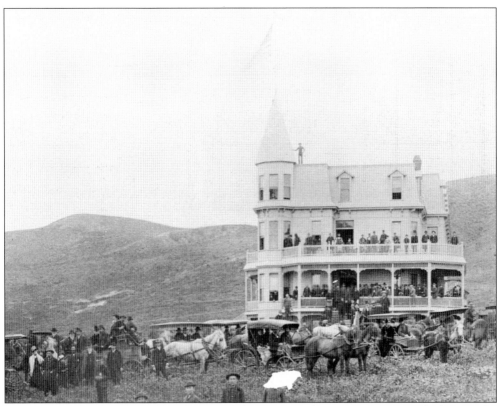

A 38-star flag flies atop the Greenleaf Hotel during a March 1888 excursion. Built that year by C.W. Harvey and Hervey Lindley for $40,000, the Greenleaf Hotel first stood at the northeast corner of Painter Avenue and Broadway but was moved to the southeast corner of Greenleaf Avenue and Bailey Street in the mid-1890s. Advertised as an upmarket tourist destination, the Victorian hotel struggled to fill its rooms and was demolished in the 1920s. (WPL.)

Another of the first permanent buildings erected following the land boom of 1887 was Hiram Gibbs's Hotel Lindley, located at the southeast corner of Philadelphia Street and Bright Avenue. By 1902, when this photograph was taken, the hotel had been purchased by *Los Angeles Herald* editor William Ivan St. Johns (future husband of journalist and novelist Adela Rogers St. Johns), lifted from its foundation, rotated to face South Bright Avenue, and renamed "Hotel Whittier." (W.E. Butler, WPL.)

GRAND EXCURSION
TO POETIC
WHITTIER

A Municipal Poem of Beauty, Sunshine, Health, Prosperity and Happiness.

Best Town of its Age in this Glorious Climate!

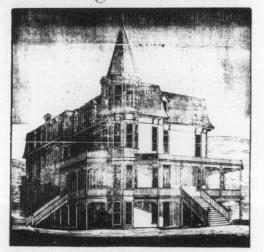

100 Choice Lots at Auction — For the Benefit of Whittier College.

100 Choice Lots at Auction — For the Benefit of Whittier College.

The above is a cut of THE GREENLEAF, the Best, Best Furnished, Best Kept, Best Appointed and Best Managed Hotel in Southern California, and is now open at

PICTURESQUE WHITTIER.

Friend, hast THOU seen far-famed

Amid more than a half-dozen advertisements for excursions to tract auctions in the March 8, 1888, issue of the *Los Angeles Herald*, one stood out for its decidedly Quakerly language and clever headline. In an item titled "Poetic Whittier," Hervey Lindley announced, "A grand excursion will run to Whittier next Saturday, November [*sic*] 10th, at which time 100 beautiful lots will be sold at auction for the benefit of Whittier College. Round trip 50 cents. Train leaves Commercial street depot at 9 a.m., returning at 4 p.m. Friend, come and invest, and thou wilst never regret it." Above, a rare piece of ephemera—a promotional piece for the auction—pushed the metaphor further, dubbing the town itself "a municipal poem" and featuring a line block of the newly constructed Greenleaf Hotel. (WPL.)

By December 1887, the real estate boom that gripped Southern California had begun its famous collapse; however, Whittier's founders continued to boost and build. Plotting a subdivision in north Whittier, C.W. Harvey, George Mason, Moses Ricker, and Hervey Lindley constructed four identical buildings at the corner of Greenleaf Avenue and Hadley Street to encourage commerce. In the background of this c. 1890 photograph, the Greenleaf Hotel stands tall, but much of northeast Whittier is undeveloped. (W.E. Butler, WPL.)

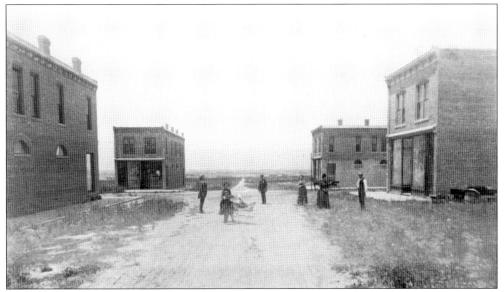

The four buildings, popularly known as "Four Bricks" after the primary material with which they were constructed, became a focal point as they were occupied by various businesses. However, while looking at this evocative photograph taken shortly after their construction, it may be difficult not to think about the recession that followed the real estate collapse of 1887, which busted many get-rich-quick "boomers" and impeded development in Whittier in the early 1890s. (WM.)

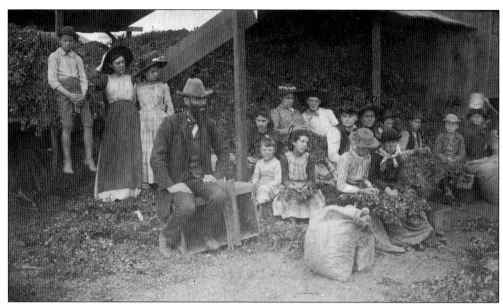

Whittier's eventual success where many other towns failed is sometimes attributed to the fact that the Quaker colonists had come to California with a noble purpose and thus a reason to stay beyond making money from real estate. Peanut cultivation represented one early attempt to make ends meet in hard times; in the 1891 photograph above, workers (mostly children) thresh a crop by hand. About the same time, sorghum ("broom corn") was raised by local farmers like Addison Naylor and Herman Williams, who sought to manufacture brooms at a factory in one of the Four Bricks buildings. According to Dr. William Coffin, "In this warm climate and fertile soil it grew too rank for the making of the best brooms." The endeavor failed. (Above, W.E. Butler, WPL; below, WM.)

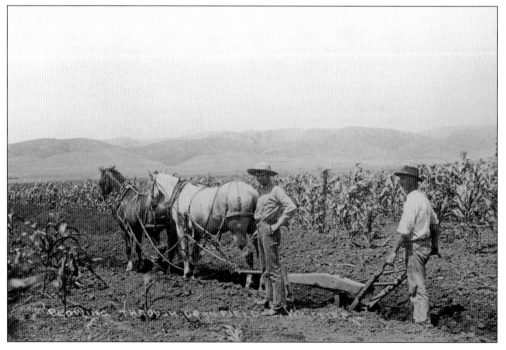

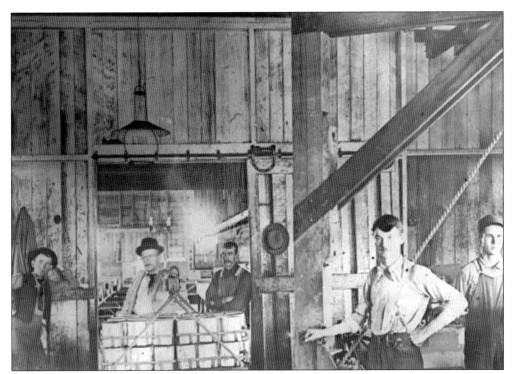

Whittier's first commercial enterprise, a cannery built near Philadelphia Street and the County Road (later Whittier Boulevard) in late 1888, provided employment and income during the hard times of the 1888–1894 recession. The Whittier Canning Company paid workers $1 per 10-to-12-hour workday to peel, slice, and can; these were low wages, but residents needed work. In the late 1880s and early 1890s, nearly everyone in town was involved in one way or another with cultivating and canning fruits and vegetables that could be grown with water obtained from the San Gabriel River. (Above, W.E. Butler, WPL; below, WM.)

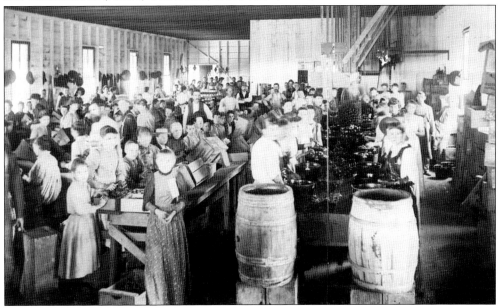

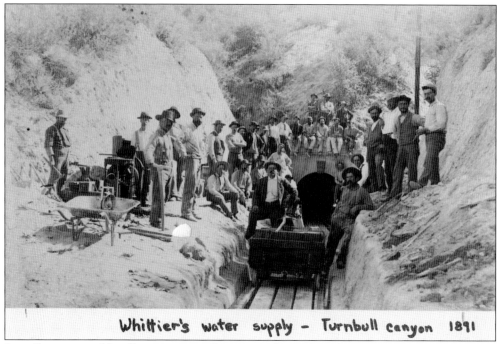

Whittier's water supply - Turnbull canyon 1891

Initially, water used for all purposes in Whittier was drawn from the San Gabriel River. By 1890, the brackish water, which had to be carted at least a mile from its source, was no longer adequate. In 1891, the Pickering Land and Water Company hired workers to construct a tunnel to bring water from Turnbull Canyon, but the project ultimately failed; the canyon water was scant and contaminated by naturally occurring oil seepage. (WC.)

During the boom of 1887, Detroit lumberman Simon Murphy purchased 2,000 acres east of Whittier but, after the collapse, could find no buyers. Murphy incorporated the East Whittier Land and Water Company and sought an adequate water supply to help make his purchase profitable. After acquiring water-bearing land near El Monte, he brought Port Huron & Northwestern Railway chief engineer Arthur L. Reed to California to figure out how to convey the water to the "East Whittier Rancho." (W.E. Butler, WPL.)

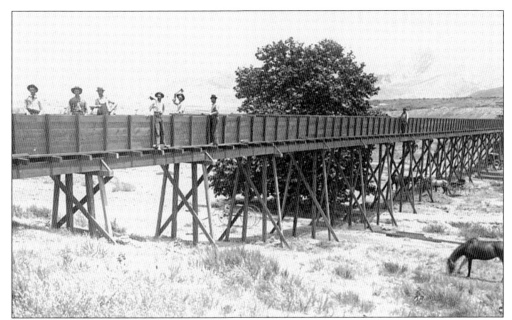

Arthur L. Reed proposed building a 12-mile-long gravity flow conduit that would run from artesian wells drilled at the El Monte site. The eventual system comprised a redwood flume across the San Gabriel River that flowed into a concrete-lined conduit with a redwood cover. Its route skirted the Whittier Hills through Sycamore Canyon (pictured here during construction), then directed water along a southwesterly course through Whittier and uphill to a reservoir on Simon Murphy's property via a pumping station at California and Second Streets. (WPL.)

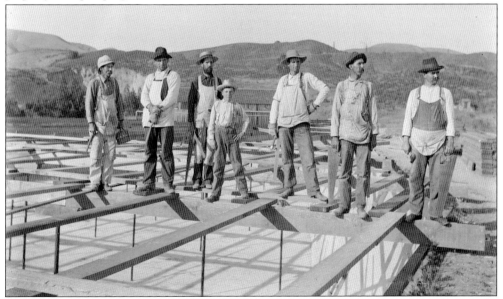

Arthur L. Reed's entire water system was completed in the summer of 1891, at which time the Pickering Land and Water Company purchased water for Whittier, building a reservoir at the east end of Bailey Street. In this 1902 photograph, the then-10-year-old reservoir is being covered. The adequate supply of clean water transformed the town, allowing for increased settlement and the large-scale cultivation, packing, and shipping of agricultural products. (WPL.)

A flume connected to the water supply brings water to irrigate newly planted trees at a Whittier homestead. Where once only scattered trees could survive, after 1891, Whittier farmers were able to grow thousands of trees on plots comprising only a few acres. (WM.)

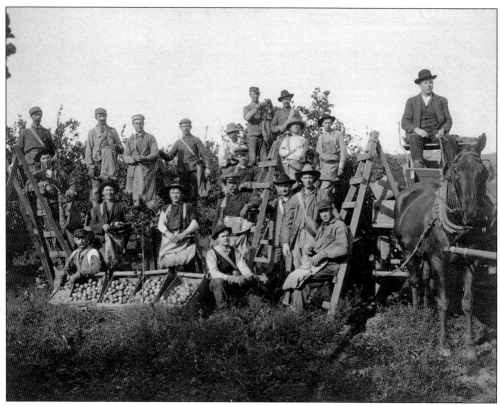

By the mid-1890s, sprawling, multi-acre orchards within town limits necessitated crews of "flat day rate" men who would climb portable ladders in order to pick oranges, lemons, and—later—walnuts and load them onto horse-drawn wagons for transport to packinghouses near west Philadelphia Street. (WPL.)

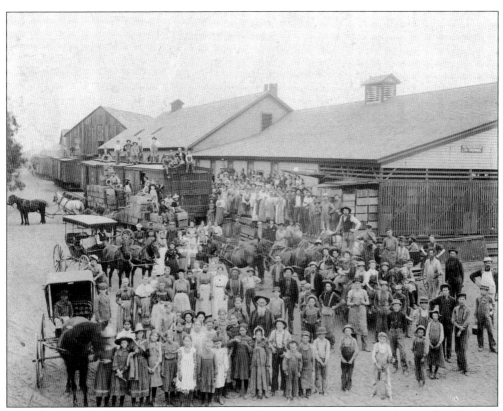

This photograph of foremen, drivers, packers, pickers, and townsfolk on and around the loading docks of fruit packing plants on the County Road (later Whittier Boulevard) captures something of the scale, operation, and makeup of agricultural production and export in Whittier in the 1890s. Typically, fruits and vegetables would come to the packinghouses via horse-drawn wagons before being sorted, packed into crates, and then loaded onto railroad cars for shipment. (WM.)

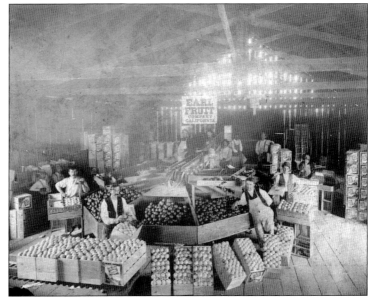

Earl Fruit Company employees sort, wrap, and load Excelsior oranges in this c. 1895 photograph. The interior is typical of fruit packinghouses of the time—dark, dusty, and decidedly rustic. (WPL.)

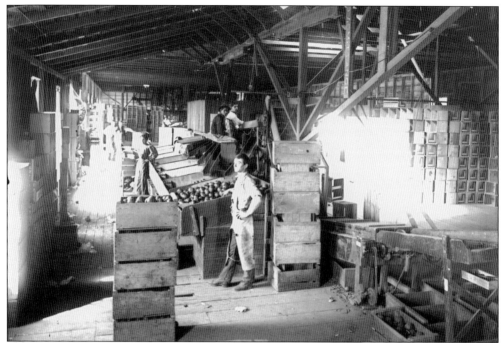

Sunlight shines through a packinghouse's loading dock doors, and workers pause to pose in this photograph from the late 1890s. A close examination of the labels on the stacked crates at left indicates that these are the Edmund Peycke Company's "Luna" oranges—the first brand to be shipped from California to England. (WM.)

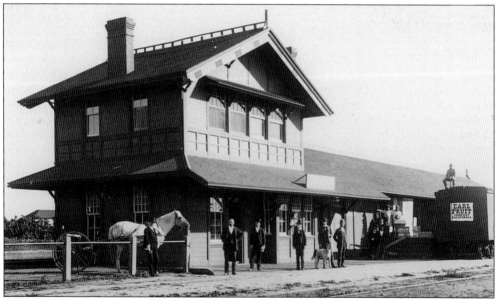

A gray, two-story passenger freight depot replaced the boxcar that had served as a temporary station after Whittier paid Southern Pacific Railroad $43,000 to build a six-mile spur from the mainline to the new town in the late 1880s. The connection, depot, and additional intracity spurs built in the 1890s facilitated the shipment of Whittier's increasing agricultural output; in this 1896 photograph, an Earl Fruit Company car sits at the loading dock. (WPL.)

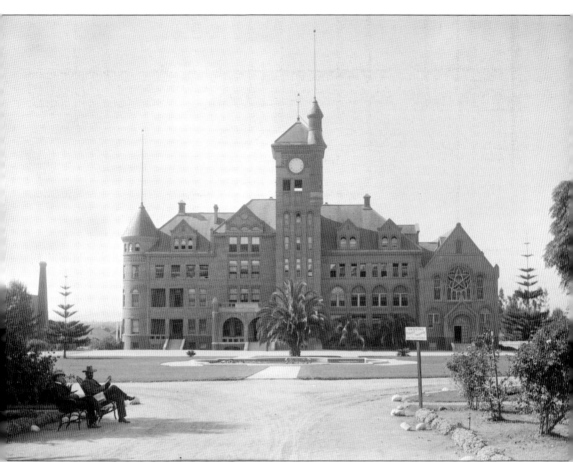

In 1889, Hervey Lindley was eager to have a proposed State Reform School for Juvenile Offenders built in Whittier in the hopes of stimulating development in the wake of the real estate collapse. Hervey and his brother, Dr. Walter Lindley (who later served as the first superintendent of the school), helped push through legislation in which California would provide $200,000 for the establishment of the institution on 40 acres provided by the Pickering Land and Water Company contingent on the state taking an option to purchase an adjoining 120 acres of land at $200 an acre. Construction began at the west end of Philadelphia Street in February 1890, and the school opened the following year. The project had the desired effect, with construction providing many needed jobs and the operation of the school stimulating Whittier's lackluster economy. The impressive four-story administration building, constructed with brick and stone, was, according to B.F. Arnold, "the best outside of Los Angeles in Southern California" and a kind of landmark "sentinel" at Whittier's western border until its destruction by fire in 1913 and total demolition in 1920. (W.E. Butler, WPL.)

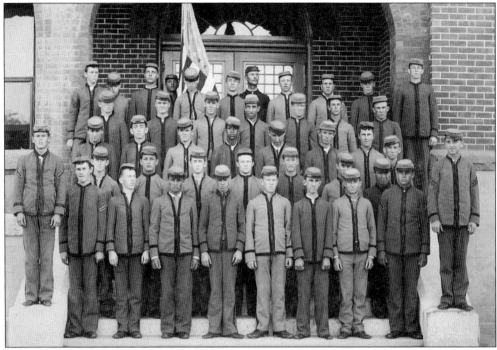

By July 1892, 253 boys and 58 girls between the ages of 10 and 16 had been committed to the renamed Whittier School of Trades and Agriculture. Administrators deployed progressive ideas about the reform and rehabilitation of juvenile delinquents. Girls were sequestered and taught household management, while boys learned operative industries. In this 1893 photograph, a group identified as "Company A" stands in front of the administration building. (WPL.)

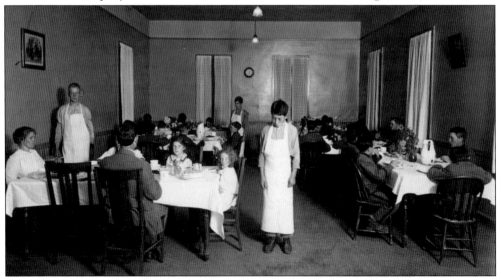

An 1891 announcement to all state courts noted, in part, that "the School shall be formative and reformative; students must form habits of industry, of study, and have manual training and they must be given moral and religious instruction, properly fed and comfortably clothed." In this late 1890s photograph, a boy assigned to the school's dining room appears to be especially forlorn about his situation. (WC.)

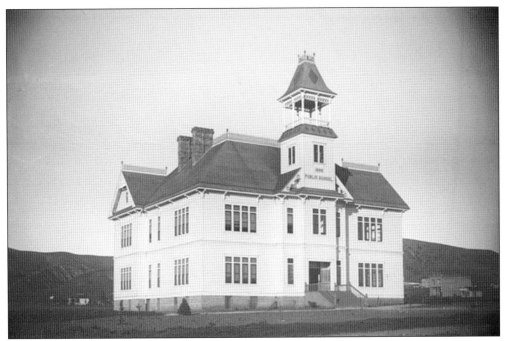

In 1889, while Hervey and Walter Lindley worked to bring the State Reform School for Juvenile Offenders to Whittier, residents established the Bailey Street Grammar School for more conventional instruction. Construction was funded by school bonds of $8,000 voted upon in 1888. The two-story schoolhouse faced south on Bailey Street, and its campus occupied an entire city block bounded by Hadley and Bailey Streets and Milton and Comstock Avenues. (W.E. Butler, WPL.)

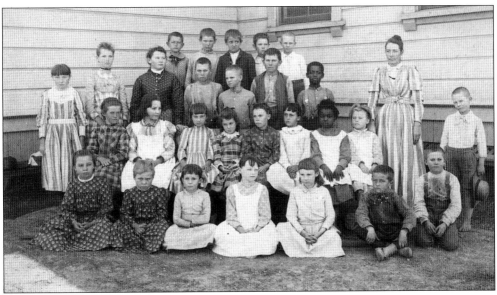

Young students and their teacher pose for a portrait at Bailey Street School in this October 1891 photograph. (Herbert A. Hale, WPL.)

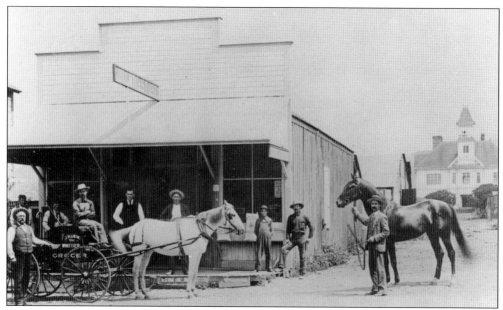

Recession or not, the pioneers who stayed in Whittier after the collapse of 1887 still needed groceries. John Henry Gwin Sr. and his son John Henry Jr. opened the town's second grocery store next to their livery business on Philadelphia Street at Milton Avenue. In this 1892 photograph, John Henry Sr. stands in the foreground next to the store's delivery wagon. The recently constructed Bailey Street School is visible in the background. (WPL.)

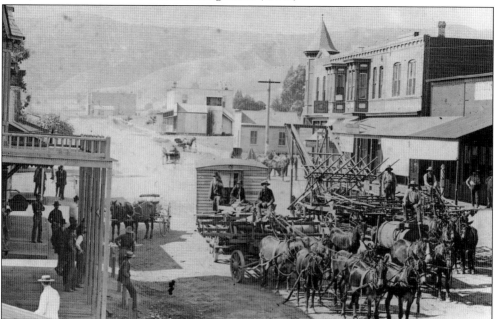

This photograph of a grain-harvesting crew heading south down Greenleaf Avenue just past Philadelphia Street provides a good impression of the Whittier landscape in the early 1890s: horse-drawn wagons, unpaved streets, wooden sidewalks, and lots of empty space. In the background is the undeveloped mesa leading up to the Whittier Hills, as well as one of the Four Bricks buildings on the southeast corner of Greenleaf Avenue and Hadley Street. (WPL.)

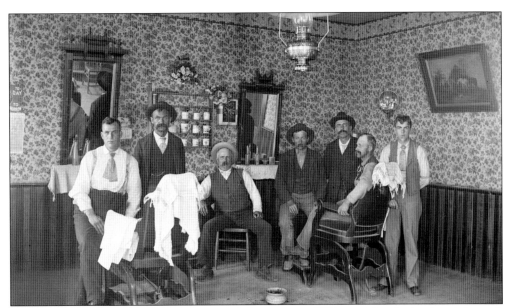

Whittier historian Virginia Mathony regarded the opening of Whittier's first barbershop (pictured) by Ethiopian immigrant Mark Anthony as a signal of a slowly but steadily improving economy in the mid-1890s; this contemporary photograph communicates something of the "Wild West" look and feel of Whittier that persisted well into the new century. (WPL.)

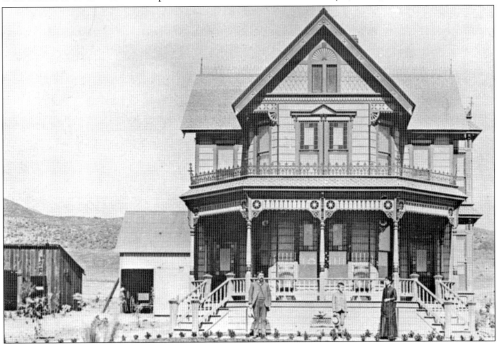

After helping to survey and subdivide the Thomas Ranch, Lindley Baldwin bought 10 acres on the northeast corner of Painter Avenue and Hadley Street, building this ornately decorated home there. After the real estate collapse, Baldwin sold the house to Washington Hadley in 1889. Although its facade has changed over the years, the house is still standing today, nearly 130 years later. (W.E. Butler, WPL.)

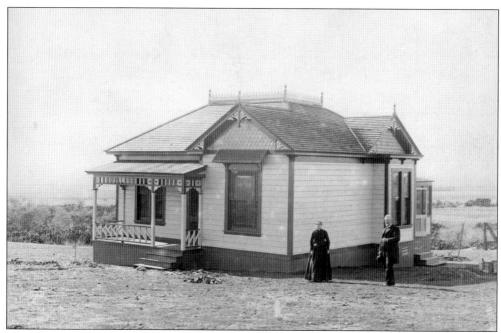

Though certainly smaller than the Lindley Baldwin House, the home of First Friends Church reverend Elias Jessup featured some of the same elaborate decoration that characterized many dwellings of the time. (WPL.)

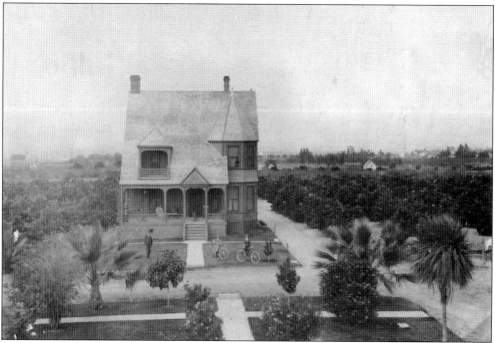

Arthur L. Reed's home was located directly across College Avenue from the house of his friend and employer Simon Murphy. Notable in this 1895 photograph are the citrus groves made possible by the municipal water system Reed designed, to say nothing of the ornamental trees and lawns in front of both dwellings. (WPL.)

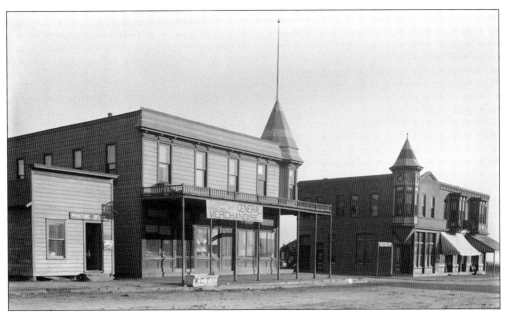

In this mid-1890s photograph, Gwin and Vernon's general merchandise store is situated at the northeast corner of Greenleaf Avenue and Philadelphia Street, next to Whittier's first printing office and across the street from the First National Bank (William Hadley, president). The initials of the Women's Christian Temperance Union are on the watering trough. (WPL.)

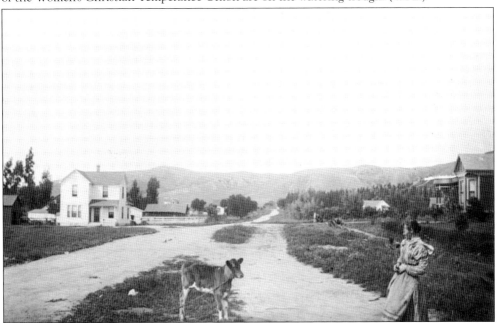

Though wagon wheel ruts in early photographs of Greenleaf Avenue and Philadelphia Street indicate an active intersection, traffic may have been somewhat lighter a few blocks north on Painter Avenue and Earlham Street (the current site of the Whittier College Campus Center). This 1894 photograph looking north up Painter Avenue features Rebecca Alvey Weeks, spouse of Whittier's first treasurer, Frederick Weeks, leading a calf across the unpaved road. (W.E. Butler, WPL.)

A solitary carriage drawn by a white horse travels north up Painter Avenue in this 1892 photograph taken from Reservoir Hill, near Painter Avenue's intersection with Hadley Street. The onion-domed Methodist church is at center, across from Central Park. Bailey Street School is the white building at left, and the Whittier State School is the large brick building beyond it. Near center-left are Philadelphia Street, Greenleaf Avenue, and the buildings occupied by the First National Bank and Gwin and Vernon's general store. (WPL.)

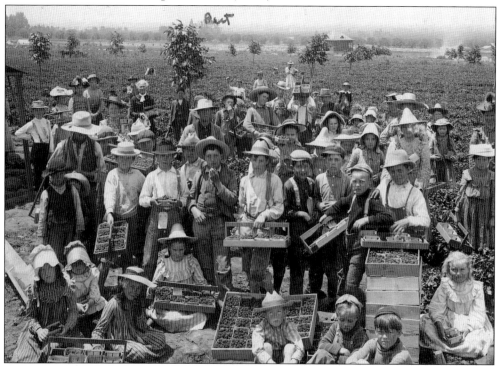

Vegetables for the household, along with berries of all sorts, were popular plants cultivated amid rows of walnut, citrus, and (later) avocado trees. In this turn-of-the-century photograph, a group of pickers—primarily youngsters from Bailey Street School—pause to display the fruits of their labor. (WM.)

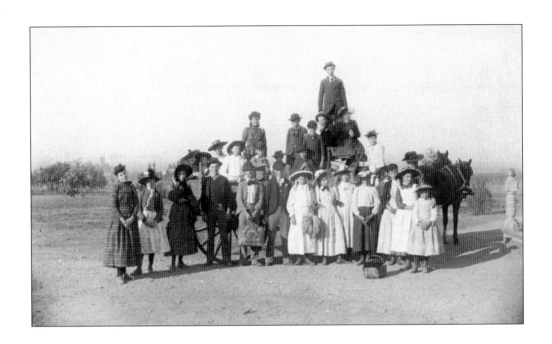

Even in the hard times of the recession of 1887–1894, there was still time for recreation and relaxation. In the 1890 photograph above, a group of children dressed in their Sunday best prepare to disembark from a wagon parked near the front steps of Bailey Street School. Below, while younger kids look on from afar, some Tom Sawyer and Huckleberry Finn lookalikes from Bailey Street School lounge and eat from lunch pails on a decidedly less formal occasion (probably a midday school break) in the spring of 1891. (Both, WPL.)

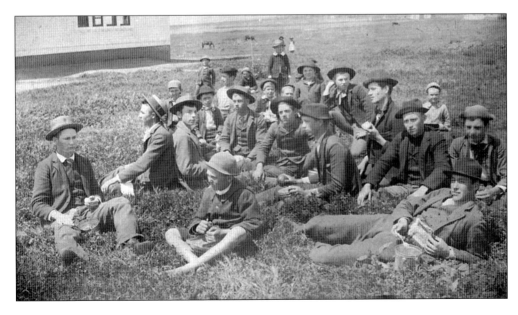

This mid-1890s eastward view up Philadelphia Street from the tower of the Whittier State School reveals Whittier just as it began to emerge from the recession. Nascent lemon groves and nursery stock at the Hamburg Nursery sprawl across the foreground, while Bailey Street School, Four Bricks, and Whittier College's Founders Hall are chief among the town's recognizable structures. In the late 1890s, William Hadley moved to disband the Pickering Land and Water Company and encouraged Whittier's incorporation. After signatures were gathered (presented by Jonathan Bailey himself to the county board of supervisors), and following Whittier's first municipal election, Whittier was officially incorporated as a city in 1898. (W.E. Butler, WPL.)

Three

FROM SLEEPY TOWN TO BUSTLING CITY
1898–1918

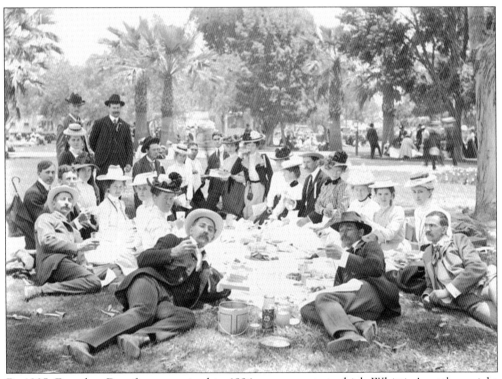

By 1905, Founders Day, first conceived in 1894 as an event at which Whittier's settlers might gather to reminisce about their earliest days in the Quaker colony, had evolved into a festive and celebratory civic holiday that included a picnic, games, and music. In the first quarter of the 20th century, Whittier evolved, too—from a quiet, rural Quaker colony into a more cosmopolitan, bustling little city. (WPL.)

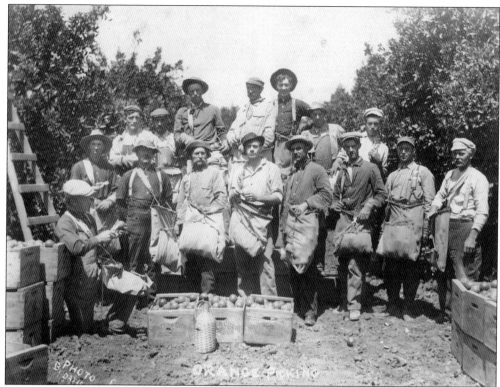

At the start of the 20th century, agriculture continued to be the most important part of Whittier's economy. A close examination of the above photograph shows that the crates bear the stamp of the Whittier Citrus Association. The 1901 formation of the cooperative and the subsequent construction of their ultramodern citrus packing plant in 1906 (pictured below after a recent grading of the road that would become Whittier Boulevard) were, after irrigation, the two developments that boosted citrus production in the area most significantly in the first part of the 20th century. By the end of 1906, nearly 1,000 carloads of oranges and lemons were being shipped by rail from Whittier each year. (Above, WM; below, WPL.)

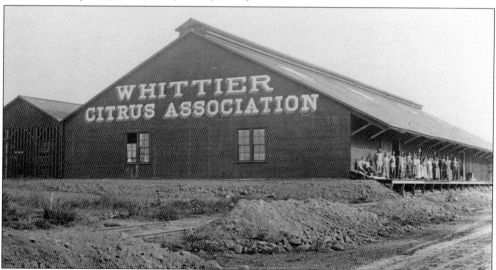

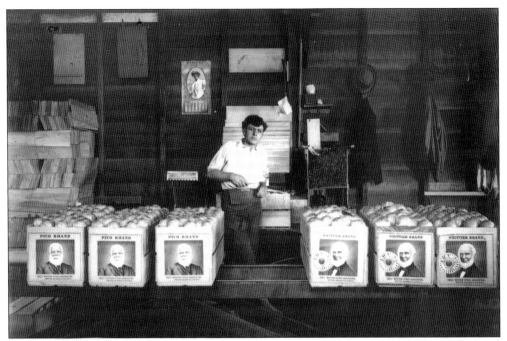

In addition to automating and industrializing citrus packing and shipping (if not picking, which was still done by hand well into the 1930s), the Whittier Citrus Association also introduced new standards of brand control. These included individually wrapping fruit in paper stamped with the California Fruit Growers Exchange "Sunkist" brand (as shown in the March 1910 photograph above, which also features two well-known Whittier fruit crate labels) and quality control (as shown in the below photograph, which features workers at the Fay Ranch washing and grading oranges prior to packing). (Above, WM; below, WPL.)

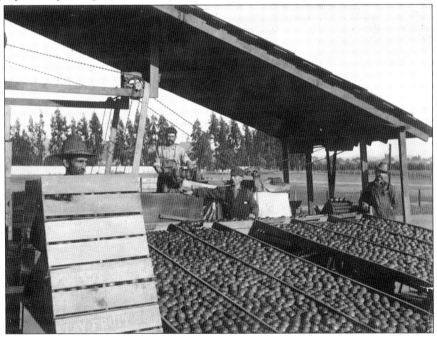

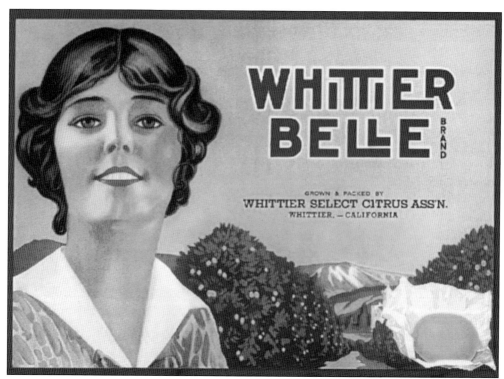

Many Whittier-area fruit crate label designs related to local history and Quaker heritage. In addition to the Whittier brand orange and Pico brand lemon labels, which featured portraits of the poet and the governor, respectively, there were also Penn brand lemons, as well as Quaker Girl, Greenleaf, and Whittier Belle orange labels. By 1910, several brands had different grades of fruits, like "Extra Fancy." Some later designs featured stylized renditions of the Whittier landscape, with hillside groves in the middle ground and the peaks of the San Gabriel Mountains looming in the distance. (Both, WM.)

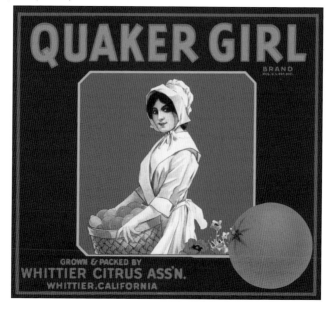

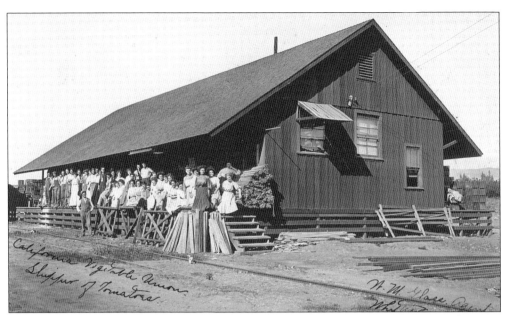

In this c. 1907 photograph, California Vegetable Union (CVU) agent William Glass and workers pose at the CVU branch south of Hadley. A note on the photograph indicates the CVU was a "shipper of tomatoes." After 1900, although citrus was the dominant crop in the area, space between trees was used to farm crops like fall and winter tomatoes, which were grown in Whittier and shipped to markets back east. (WM.)

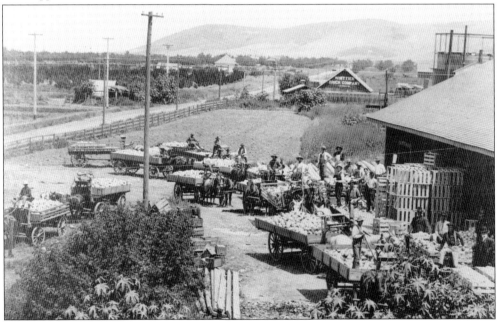

In addition to tomatoes, Whittier farmers were major producers of Winningstadt cabbage. In 1909, of the 1,000 carloads of cabbage shipped east from Southern California, Whittier's CVU branch sent 600. At first glance, the above photograph looks as if it might have been taken in the 19th century; however, it depicts farmers unloading cabbage at the CVU branch in 1910, well after the installation of power lines and utility poles. (WPL.)

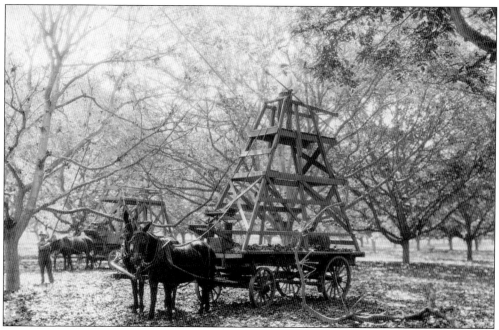

Writing for Whittier's University Farmers' Institute for the *Pacific Rural Press* in 1906, Ralph McNees noted, "In the rich, warm soil of our Southland, the tree found the most favorable conditions for a nourishing growth. We did not have to raise walnuts. They raised themselves. To be the owner of a good walnut grove was considered as fortunate as to be a banker." With Whittier serving as a major center for walnut production by 1900, harvests brought in big returns for backyard family-run operations, as well as for big Whittier ranches like the ones in these c. 1910 photographs. Above, workers stand on scaffolds placed on mule-drawn wagons to prune high branches; below, washed walnuts dry in the sun before being graded and placed in canvas sacks to be taken to the packinghouse. (Both, WPL.)

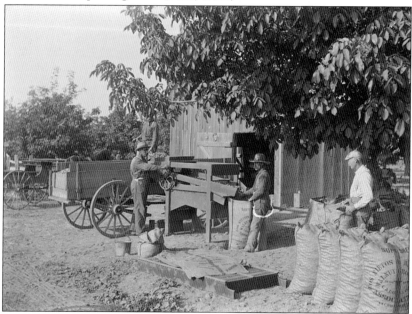

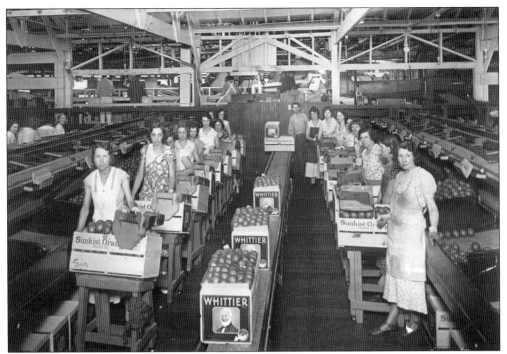

One of the most striking changes in agricultural packing and shipping in Whittier in the first quarter of the 20th century was found in working conditions on the packinghouse floors. As consumer demand increased, growers insisted on new standards of productivity, cleanliness, and quality control. Packinghouses in the 1890s were rough-hewn, dark, dusty, and hot, but by the 1920s—as shown in these photographs from the Whittier Citrus Association plant—the houses were clean, open, fan-cooled, lit with electric lamps, and automated. (Above, WM; below, WPL.)

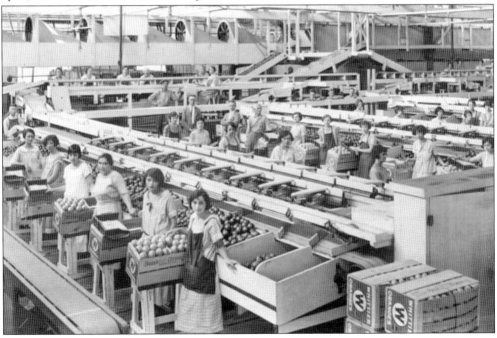

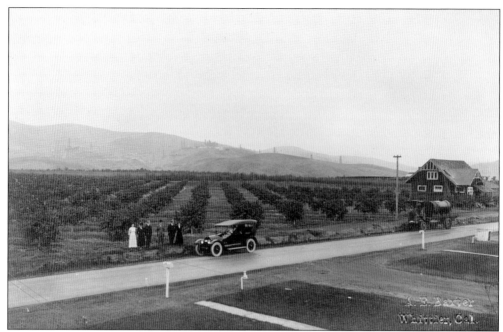

The c. 1915 photograph above shows the recently paved County Road (later Whittier Boulevard) and the extent to which the agricultural industry dominated the landscape. Extensive citrus and walnut orchards endured well into the middle of the 20th century. Aside from the paved road, more than a few trappings of modern living are featured here, including the touring automobile and tank truck, power lines and utility poles, water spigots and mailboxes, grass lawns, and—on the crests of the Whittier Hills in the distance—signs of another industry that dominated the landscape of 1900s Whittier: wooden oil derricks. B.F. Arnold's Home Oil Company first struck in Whittier in 1898. By the 1920s, large sections of the Whittier Hills were a veritable forest of derricks. (Above, WPL; below, WM.)

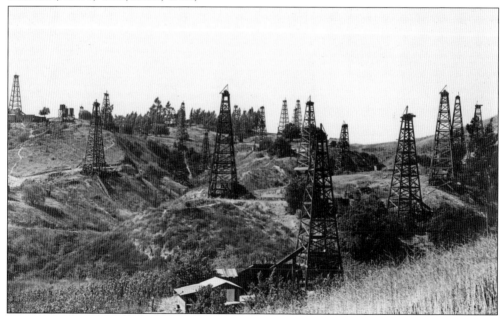

Whittier water system financier Simon Murphy first drilled for oil on his east Whittier lands in 1899, striking two years later. The May 1907 photograph at right, from the front page of the *Whittier News*, depicts a gusher on Murphy's Well No. 16, driven to unusually great heights by "tremendous gas pressure." (The oil derrick is approximately eighty feet tall.) Below is a typical setup for the importation of oil—tank cars idle on a railroad spur, waiting to be filled from huge wooden vats in which crude oil drawn from Murphy Oil Company wells had been stored. (Right, WPL; below, W.E. Butler, WPL.)

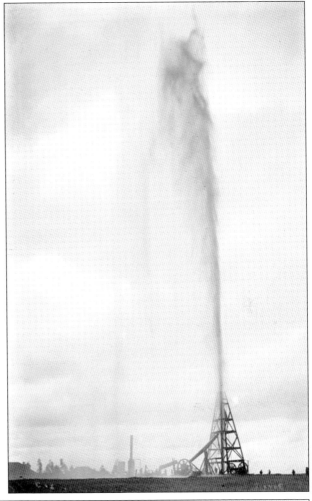

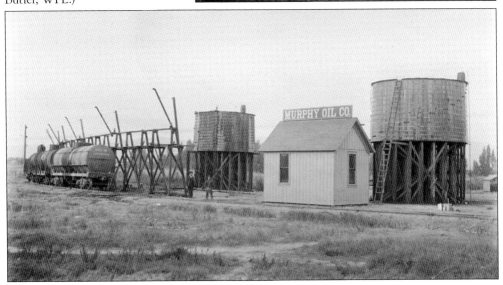

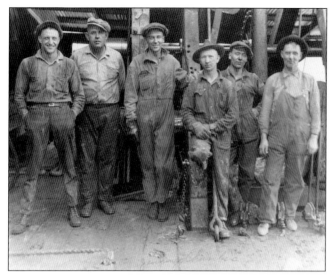

An oil crew from the Whittier-adjacent Getty Oil Fields is pictured here around 1921. By June 1917, production in the area reached 96,000 barrels monthly. A 1924 *Whittier News* article suggested that the influx of oil workers and their families meant new homes, modern utility systems, larger schools and churches, and the beginnings of a metropolitan atmosphere, indicating "the city was passing through the period of adolescence usual to the 'big town–small city' jump." (WPL.)

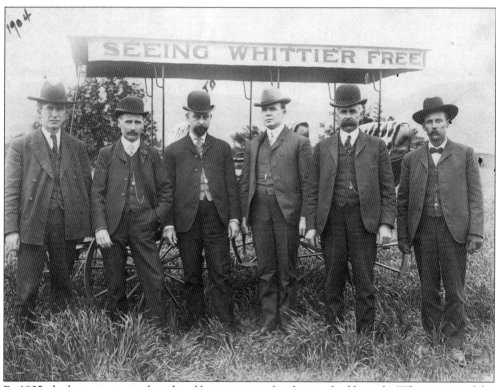

By 1905, the booming agricultural and burgeoning oil industries had brought Whittier out of the economic depression of the 1890s and its attendant real estate slump. "Seeing Whittier Free" was the slogan of the Whittier Realty and Investment Company, pictured in 1904 with the specially outfitted carriage realtors used to convey potential buyers to available lots and homes along graded but yet-unpaved streets. (WM.)

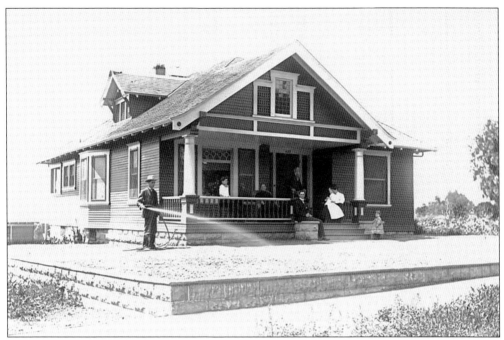

This 1907 photograph shows Edward and Esther Bailey's home—and features Esther's family—on what is now the 6200 block of Painter Avenue. Built from scratch (but also from kits), post-1900 homes in Whittier tended to be more upmarket than homes built just a few years earlier and, thanks to a reliable water supply, could support front lawns, ornamental trees, and backyard gardens. (WPL.)

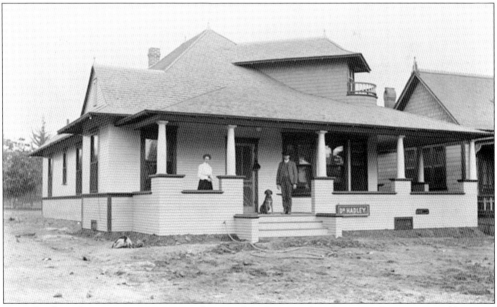

A garden hose lies across a conspicuously grass-free front yard at the recently constructed home of Dr. F.H. Hadley on north Bright Avenue in 1902. In the *Souvenir of Whittier* photo book published by the Whittier Volunteer Fire Department just two years later, Dr. Hadley's home features a wide concrete walkway leading from the sidewalk to the steps and bounded by lawn. (WPL.)

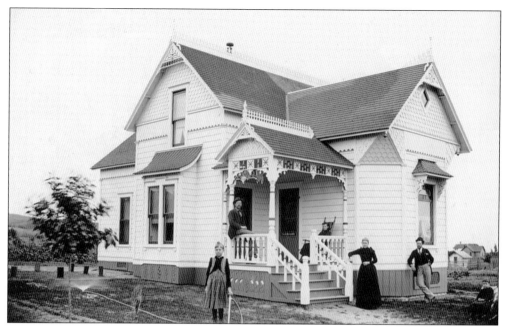

By 1905, even houses built in the previous decade had been plumbed, and more than a few featured upright spigots in the center of their front yards. In this photograph of Verus Reynolds's home at Friends Avenue and College Street, a newly planted lawn is being sprinkled with water via just such a setup. (W.E. Butler, WPL.)

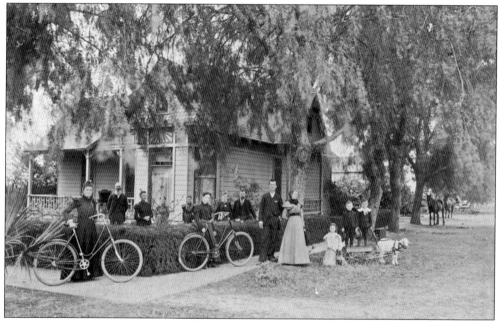

The family of city recorder N.D. Ellis—and some animal friends—pose under shade trees next to Ellis's home on south Bright Avenue around 1905. Bicycles are featured in many photographs from the first decade of the 20th century in Whittier. At a time when roads were unpaved, horses expensive to feed and stable, and automobiles luxury items, bicycles offered economical and reliable transportation. (WM.)

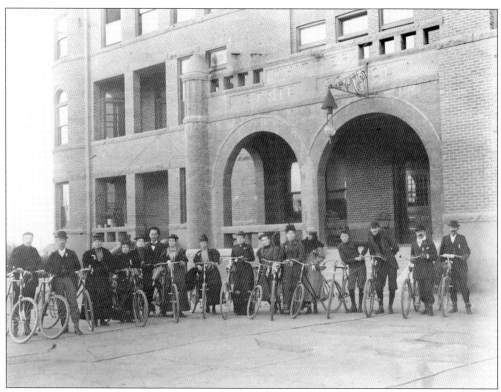

Although bicycles were mainly for getting around town (and the occasional race; see chapter four), some Whittierites ventured farther afield. Formed in the late 1890s, the Columbia Bicycle Club hosted long rides that often took residents outside city limits. In this photograph from January 1, 1898, the club poses in front of the Whittier State School before a trek from Whittier to Pasadena to see the Rose Parade. (WM.)

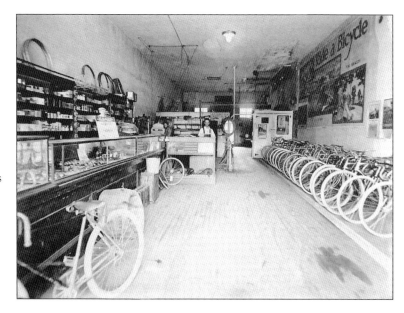

In the first part of the 20th century, Whittier's cyclists could buy or rent bicycles and get their bikes repaired at two locations: Saunders Brothers Cyclery on Greenleaf Avenue (pictured here in 1901), or B.R. Stanfield's Whittier Cyclery on Philadelphia Street. (WM.)

THE WHITTIER REGISTER

VOL. XII WHITTIER, CALIFORNIA, SATURDAY, NOV. 7, 1903 NO. 40

SIMPLY A LITTLE SOUVENIR

Of the Completion of the Whittier Electric Line. Preserve It for Your Children's Children

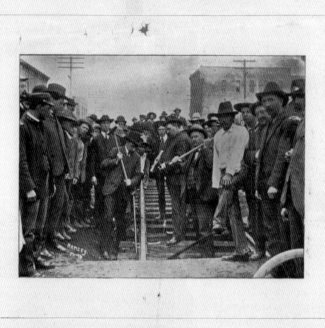

Driving the Last Spike on the Whittier Line of the Pacific Electric Railway System

Mayor Clayton standing on the right; Postmaster L. M. Baldwin in the center about to drop his tomahawk; Dr. W. V. Coffin on the left with his battle-axe raised ready to miss the spike; the Mexican on the right in his shirt sleeves drove the first spike on the Whittier electric line at 10 a. m. Oct. 3, 1903, and was there at the finish.

DRIVING OF THE SPIKES

At 10:10 a. m. October 3rd, 1903, Ascension Medino, a peon, drove the first spike on the Whittier line of the Pacific Electric Railway.

At 10:10 a. m. today, November 6, Mayor C. W. Clayton, Postmaster L. M. Baldwin and Dr. W. V. Coffin, assistant superintendent of the State school, drove the last spike, a silver one.

Five minutes before Capt. Chas. Kinsler, and S. W. Barton, drove a spike on behalf of the Whittier Co., No. 68, Uniform Rank Knights of Pythias.

And tomorrow we will paint the town red!

REGISTER'S RAILROAD EDITION

Saturday, November 14th, the REGISTER will issue a handsome "Electric Railroad Edition." It will be profusely illustrated with half-tone pictures of scenes in and about Whittier and along the electric line. If you would secure copies of this edition to send east, it will be necessary to order them at once, as the demand for them will be unprecedented in Whittier. Advertisers wishing space in the special should secure the same immediately.

Whittier celebrated the completion of the Pacific Electric line from Los Angeles to Whittier on November 7, 1903. The *Whittier Register* printed a keepsake souvenir for the occasion with a photograph featuring the driving of the last, golden spike by Whittier College board member Dr. W.V. Coffin, postmaster L.M. Baldwin, and mayor C.W. Clayton, as well as Ascension Medino (in shirt sleeves), the worker who drove the first spike just over a month before, on October 3, 1903. The Whittier Pacific Electric tracks initially ran across what is now Whittier Boulevard up to the intersection of Philadelphia Street and Greenleaf Avenue, where the tracks then turned south to their terminus. Just a few years later, Whittier moved the Pacific Electric depot to Philadelphia and Comstock Avenue, which became the new end of the line. (WPL.)

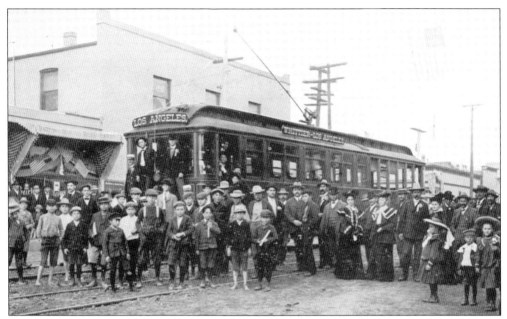

One of the most well-known images of early Whittier features the celebration around the city's first-ever Pacific Electric red car on November 7, 1903, at the yet-unpaved intersection of Greenleaf Avenue and Philadelphia Street. The connection to Los Angeles meant that one no longer had to work in Whittier to live there—an advantage touted by boosters in contemporary advertisements and circulars. (WM.)

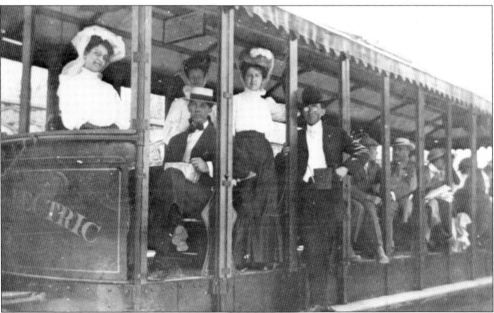

At its height, the Whittier–Los Angeles Pacific Electric line ran between the nascent bedroom community and the growing metropolis 27 times each day. The trip took 45 minutes. Whittier's population growth in the early 1900s can be attributed not only to the agricultural and oil industries but in part to this reliable mode of public transportation, as an increasing number of residents elected to work "Downtown" but call Whittier home. (WC.)

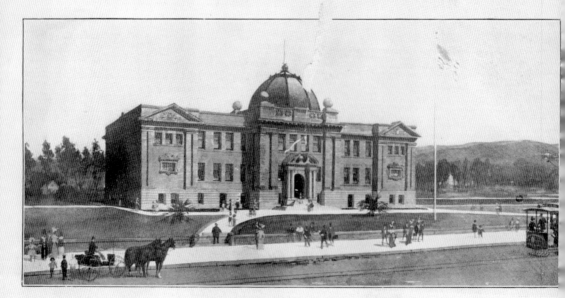

WHITTIER UNION HIGH SCHOOL

The frontispiece to an early-1900s booster publication called *Whittier: The City of Homes* is this artist's rendition of what would become Whittier High School. The existence of (and need for) a high school was a clear indication of a city's success in many contemporary advertisements and accounts; indeed, as *City of Homes* author Albert B. Pearce wrote, "Perhaps the most striking evidence of the ambition of this rising city is the new high school, which, when completed, will cost $75,000." Note the Whittier Hills in the background and a Pacific Electric red car headed east up Philadelphia Street. The school opened in March 1905. (WM.)

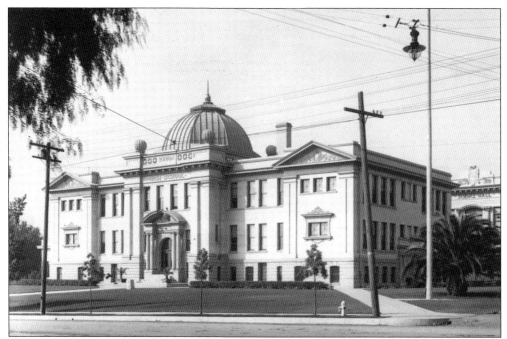

This photograph shows Whittier High School as it appeared in 1910, looking more or less the same as in the artist's rendition from five years before. By 1909, additional buildings had been constructed, including the new science hall visible in the background. In 1933, a 6.4-magnitude earthquake in Long Beach rendered most of Whittier High unsafe, necessitating that the structures be rebuilt or—as with the original building—demolished outright. (WM.)

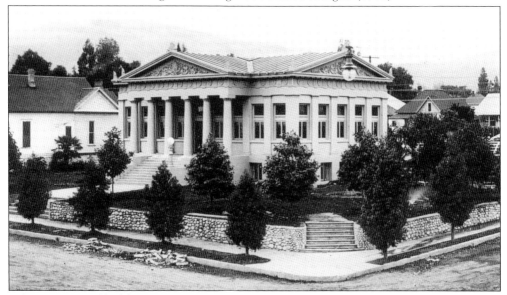

Whittier's first public library was an Uptown storefront reading room established by the Women's Christian Temperance Union. In 1905, Andrew Carnegie donated $12,000, which was augmented by $10,000 from private donations, to help build a Carnegie library at the northeast corner of Greenleaf Avenue and Bailey Street. Located in a miniature park, the structure was demolished in 1955 when the library moved to a building at the new civic center. (WPL.)

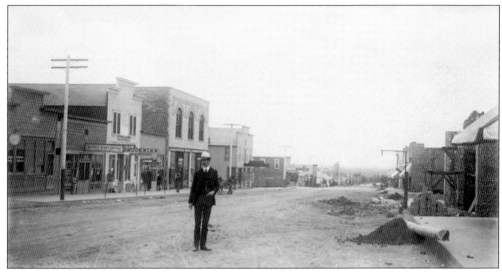

Despite developments like concrete sidewalks, power lines, and water mains, in the early 1900s, much of Whittier still had a "Wild West," frontier town feel to it, with unpaved streets and rough-hewn structures, as in this photograph looking west down Philadelphia Street from Greenleaf Avenue prior to the Pacific Electric tracks being laid. This 1902 photograph features Fred "Shorty" Foster, the city's first marshal. (WPL.)

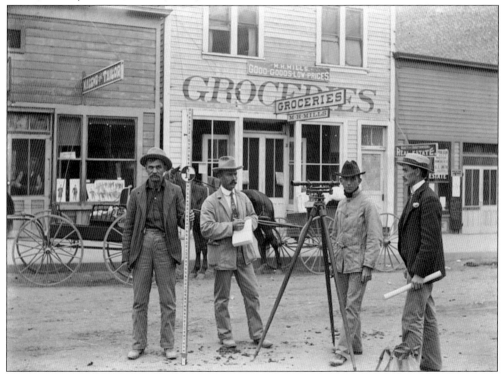

Surveying crews, like this one led by city engineer Ed Bailey (at far right), helped plot the course of utilities and aided in the improvement of streets. Though much of Whittier—outside the central business district—remained unpaved well into the 1920s, most roads were graded and oiled by 1910. (WPL.)

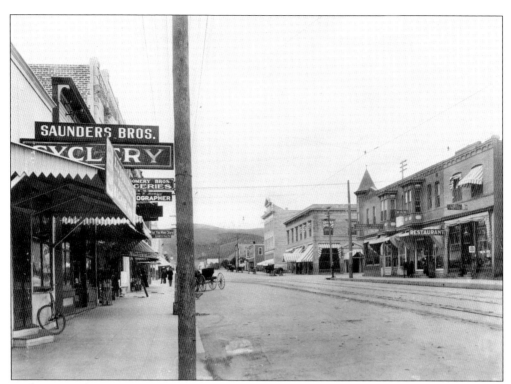

A glance north up Greenleaf Avenue in this c. 1907 photograph reveals the newly laid Pacific Electric tracks (turning around the southwest corner of Greenleaf Avenue and Philadelphia Street) and demonstrates how uniform a graded road could be, even if it was unpaved. (WPL.)

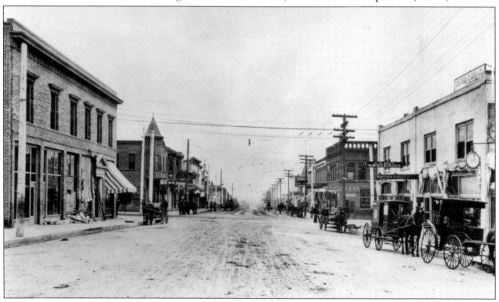

On the other hand, a southward glance in the opposite direction just a few years earlier (after the Pacific Electric tracks were laid but while the public library still occupied a storefront on the west side of Greenleaf Avenue) shows how variable unpaved streets could be. It was an annoyance that cyclists—and, increasingly, automobile drivers—wanted remedied. (WPL.)

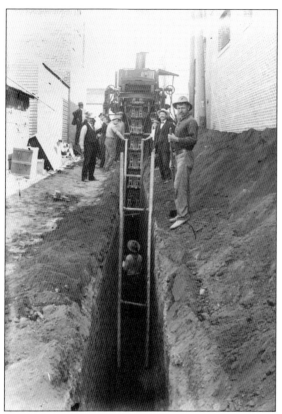

Whittier's unpaved streets afforded some advantages. A December 1908 *Whittier Daily News* editorial argued, "The one great item now lacking is an adequate sewer system, and without this Whittier can scarcely expect to claim all the honors to which she should be entitled." In June 1909, the city council granted a contract to M.L. Hostetter of Los Angeles, whose workers did not have to tear up concrete to install the new pipes. (WM.)

Hostetter looked to employ "Whittier men who are willing and want to work" and found a labor force immediately. Construction on the sewer system began just a few weeks after he won the contract. Hostetter's steam-powered ditchdigger helped him and his team complete the system by September 1910 and proved to be of particular interest to young Whittierites, who gathered at construction sites throughout the process to watch the machine in action. (WM.)

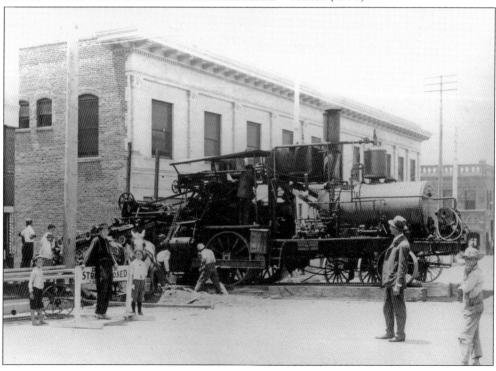

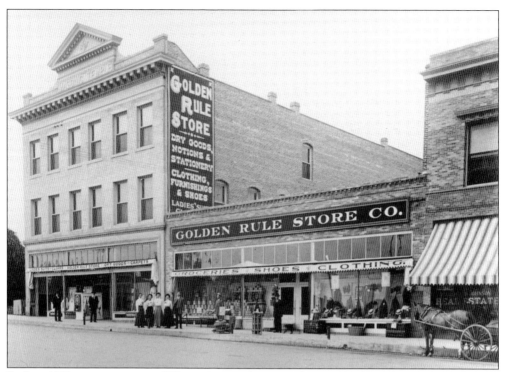

By late 1910, many streets in Whittier's main business district had been paved with concrete, though horse-drawn vehicles still abounded. Here, on the east side of Greenleaf Avenue just north of Philadelphia Street, employees of the Golden Rule Store pose outside the workplace, next to Whittier's impressive Masonic Temple. (WPL.)

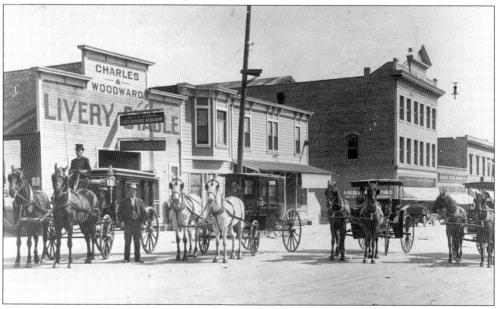

In this c. 1910 photograph, a horse-drawn funeral procession makes its way up the recently paved Greenleaf Avenue on its way to Mount Olive Cemetery on Broadway, pausing just past the Masonic Temple and Golden Rule Store and outside the Charles & Woodward Livery Stable. (WPL.)

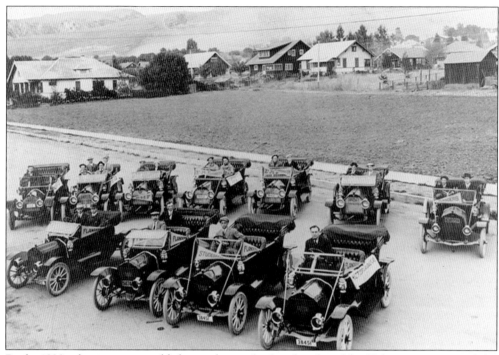

By the 1920s, the situation would change, but in the first decades of the 20th century, automobiles were still expensive curiosities out of the reach of most Americans. They were also an impractical way to get around, considering most roads remained unpaved in all but the biggest cities, and fuel stations were few and far between. In these 1912 photographs, pioneer motorists take advantage of Whittier's recently paved streets to show off their cars and try them out on the city's steepest routes. Above, Studebaker-Flanders roadster and touring car owners line up on north Greenleaf Avenue past Hadley Street. Below, at the corner of Philadelphia Street and Greenleaf Avenue, motorists gather in the wake of a rally. The Hotel Greenleaf is in the background. (Above, WPL; below, Niemeyer Studio, WPL.)

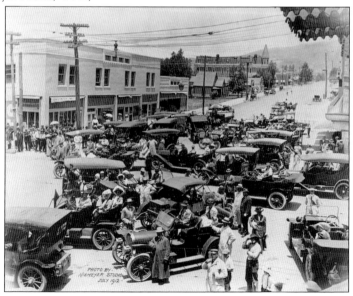

Painter Avenue was paved at a relatively late date, but there can be little doubt that the increase of automobile traffic in Whittier in the late 1910s and 1920s was the reason. This is a photograph of Painter, which was graded in 1904 before being paved. (WM.)

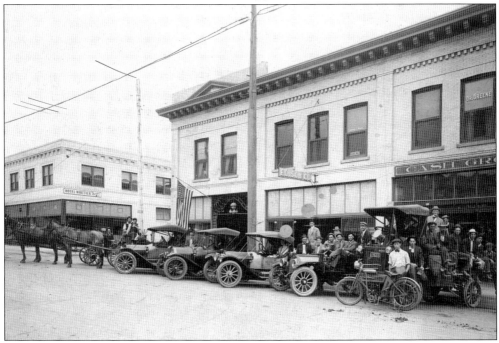

A 1917 chamber of commerce brochure touted that "A beautiful white [concrete] way has just been completed on Philadelphia, at a cost of $8,000." In this near-contemporary photograph, drivers line up their cars on the north side of this recently paved street and directly in front of the Berry Building, a two-story structure erected by Whittier rancher and entrepreneur Truman Berry between Bright and Washington Avenues some 10 years earlier. (WM.)

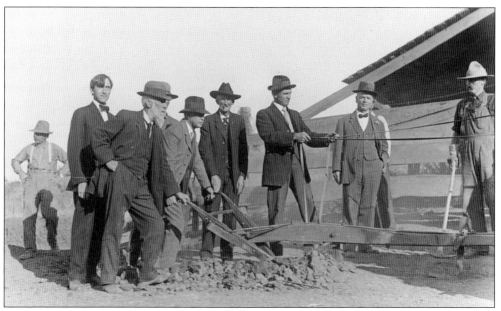

A road through Turnbull Canyon and over the Whittier Hills was proposed as early the late 1890s to facilitate commerce—and access the hilltops and their panoramic views—but it was not until 1913 that ground was broken and construction began on Turnbull Canyon Road. (WPL.)

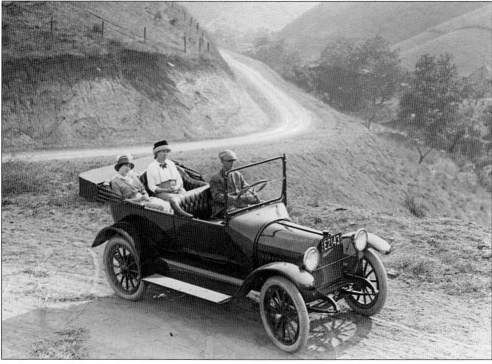

Early issues of the *Quaker Campus* newspaper at Whittier College indicate that motoring tours to the top of Turnbull Canyon to look at the moon were not uncommon, nor were Sunday drives or overnight stays at cabins on oil company leases. In this 1914 photograph, Ralph Robbins and unidentified passengers pause near the recently constructed Turnbull Canyon Road. (WPL.)

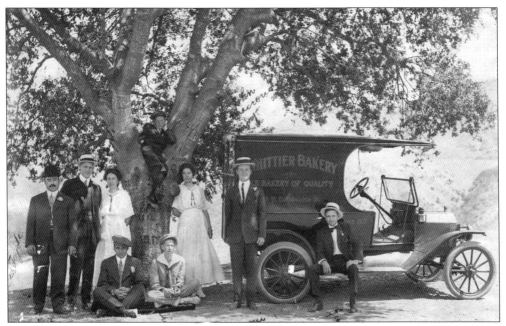

Turnbull Canyon Road allowed employees of the Whittier Bakery to picnic and pose with the delivery truck in this c. 1915 photograph. By the second decade of the 20th century, many Whittier businesses—including a steam laundry and dairy—relied on motorized trucks to deliver goods and services. (WPL.)

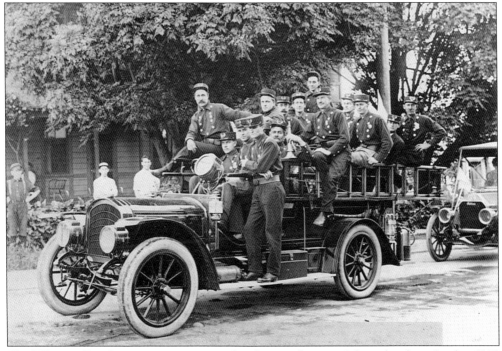

The Whittier Fire Department was an early adopter of automobile technology. In this 1908 photograph, the all-volunteer department has piled onto their first fire truck on an unidentified, unpaved residential street, ostensibly as part of a municipal parade. (WPL.)

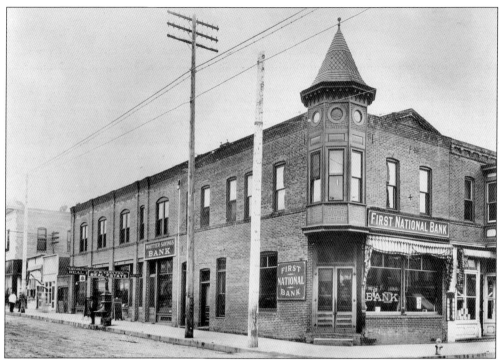

In the early 1900s, many Whittier boosters touted the fire department and its apparatuses, which included the more than 100 fire hydrants connected to the city water system. In this c. 1905 photograph of William Hadley's First National Bank at the southeast corner of Greenleaf Avenue and Philadelphia Street, the roads remain unpaved; however, a brand-new fire hydrant pokes out of the concrete sidewalk in the foreground at right. (WPL.)

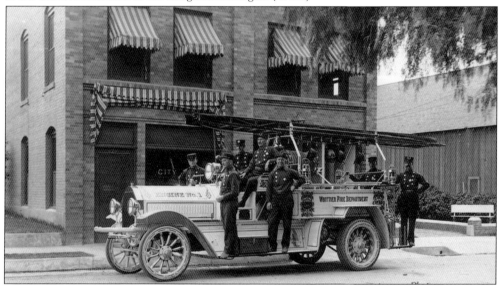

This c. 1915 photograph shows members of the Whittier Fire Department posing with Fire Engine No. 1—their third fire truck in 10 years—just outside the department's headquarters on Comstock Avenue south of Philadelphia Street. By this time, even the smaller streets off Philadelphia Street and Greenleaf Avenue had been paved. (WPL.)

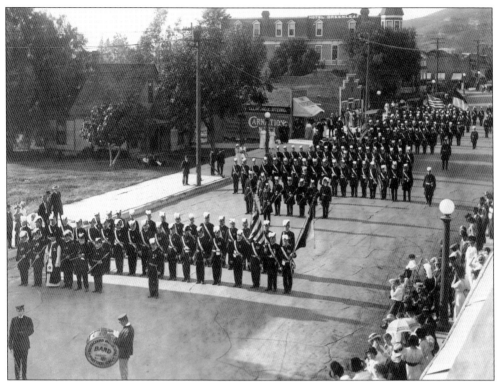

The fire department may have participated in this Easter 1914 parade down Greenleaf Avenue. Featured in the photograph is the Freemason York Rite Commandery No. 51, with the front line stopped near Whittier's Masonic Building, from which this photograph may have been taken. The Hotel Greenleaf, located at the southwest corner of Bailey Street, is visible (in the background), as are electrical lines on the west side of the street. (WM.)

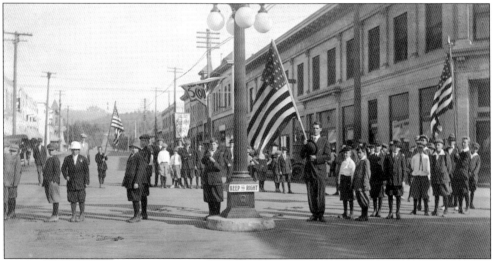

Just around the corner, Boy Scouts from Troop No. 1 take a break from the Easter 1914 parade at the intersection of Philadelphia Street and Greenleaf Avenue, where a newly installed traffic signal advises motorists to "Keep to Right." At right in this eastward-facing view, the new Emporium Building joins up with First National Bank, which has a new facade. (WM.)

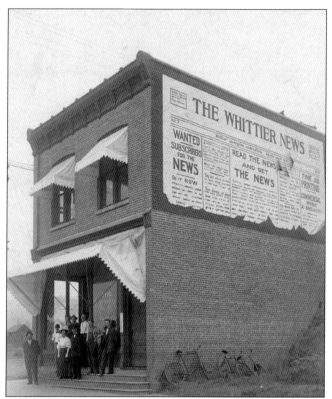

In its first instantiation, the *Whittier News* occupied the "Brick" on the southeast corner of Greenleaf Avenue and Hadley Street. On the building's south-facing side was a mural depicting the top half of a front page. The first issue appeared in 1900 as a weekly; in 1904, the paper became a daily, and its name changed accordingly (to *Whittier Daily News*). In 1912, R.B. Kennedy, father of renowned food writer M.F.K. Fisher, bought an interest and became the paper's editor. (WPL.)

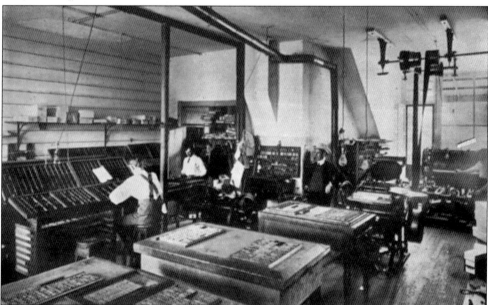

A rare glance into the *Whittier Register* pressroom from the early 1900s reveals how extraordinarily laborious it was to print a newspaper in the first decades of the 20th century. By the 1920s, most Whittier newspapers were printed using Linotype machines, but until that time, every page of every newspaper had to be set by hand with metal typefaces before being inked and printed on a printing press. (WC.)

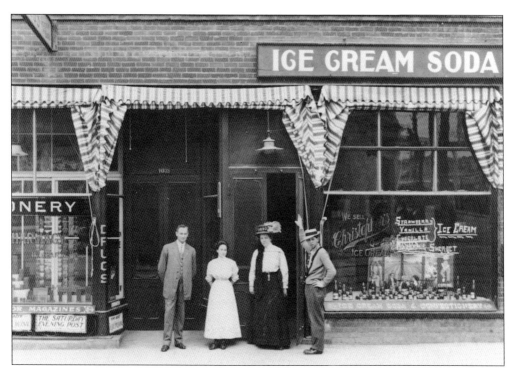

The Idyllwild Sweet Shop, located at the southwest corner of Greenleaf Avenue and Philadelphia Street, was one of several soda fountains established in Whittier by 1915—another sign of the town's growth and changing character, as more and more businesses catered not to necessities but to leisure and amusement. In the c. 1910 photograph above, the soda fountain staff poses in front of the shop's windows. Below, in a near-contemporary photograph, one can see the shop's location and three means of transportation: horse and buggy, automobile, and the Pacific Electric line tracks, which are turning around the corner through the recently paved streets. (Both, WC.)

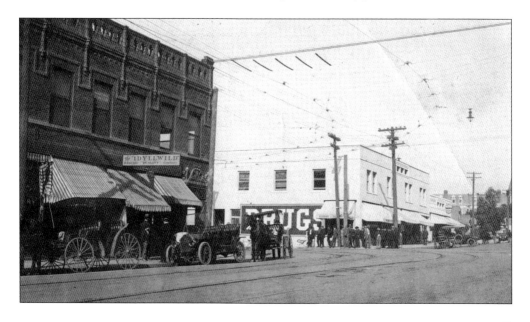

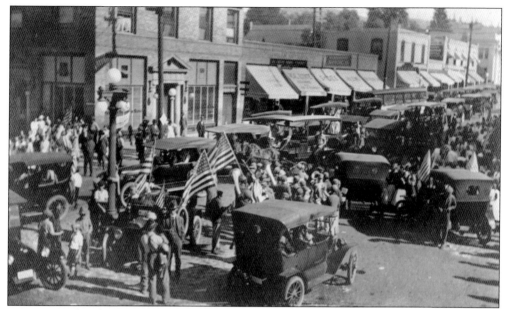

Juxtaposing the above photograph of Armistice Day in 1918 (at the intersection of Greenleaf Avenue and Philadelphia Street) with the below photograph of Wilson's Whittier Orchestra starting out for a concert around 1905 offers sharp insight into some of the ways Whittier changed in the first two decades of the 20th century. In 1900, Whittier was an unpaved, sleepy, rural hamlet of just 1,500 people. By 1920, Whittier's population had surged to 8,000, and the active place—now a proper city—could boast not only an ideal location and climate but also paved streets; good government, schools, and churches; concrete and brick commercial buildings; and up-to-date utilities. (Above, WC; below, WPL.)

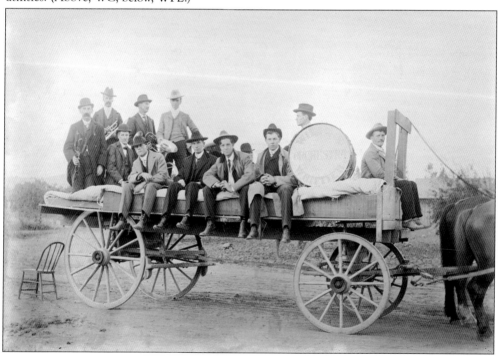

Four

INTERLUDE
WHITTIER COLLEGE

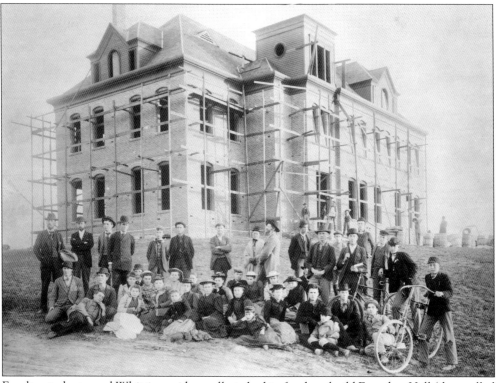

Faculty, students, and Whittier residents all pitched in funds to build Founders Hall (then called the "College Building"), the first structure to go up on what would become the Whittier College campus. Construction on the impressive edifice began in 1893; at this stage, the facade had been built, but its signature bell tower had yet to be constructed. Among the crowd are Dr. William V. Coffin (standing second from left) board president Arthur Trueblood (standing third from right); and early professors John Chawner (standing sideways at center) and B.M. Davis (standing at farthest left). Founders Hall remained the most dominant structure on campus until 1968, when it was destroyed in a fire. (WC.)

The school began as a small preparatory academy, but with financing from local philanthropists, it was expanded to form Whittier College. This photograph of Whittier Academy students and professors features former principals William V. Coffin (1892–1894; standing at far left) and John Chawner (1891–1892 and 1895–1896; seated second from left). After serving as principal, Coffin became president of the board—a post he held for nearly 20 years. He was also instrumental in bringing the Carnegie Library to Whittier. This photograph was taken in 1891 in front of the Whittier Hotel. (WC.)

From the earliest days, the Quaker settlers dreamed of having a Friends College in Whittier. After meeting in late 1887, the newly formed "Whittier Educational Association" laid down rules for their new board, the majority of whom had to be Quaker, and elected Samuel Coffin as president. Establishing a fund large enough to begin their Friends College, however, proved less easy. (WC.)

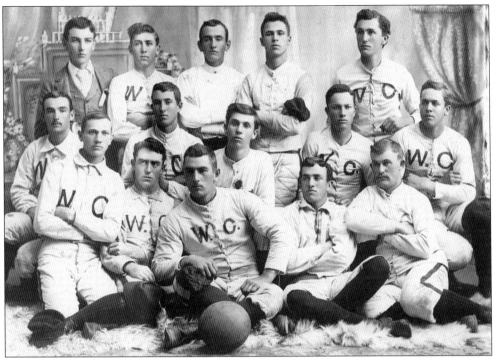

Even in 1893–1894, before Founders Hall was built, Whittier College had a football team. Members of this first team were students of the Whittier Academy and local boys. From left to right are (first row) Tom Weed, Lou Chambers, George Hunnicutt, Clarence Knox, and Bill Duggar; (second row) Ed Coryell, Carl Judson, Glenn Arnold, Otha Ellis, and Ernest Gregory; (third row) Clyde Baldwin, Clark Underwood, Luther Healton, John Coverly, and Elmer Jessup. (WC.)

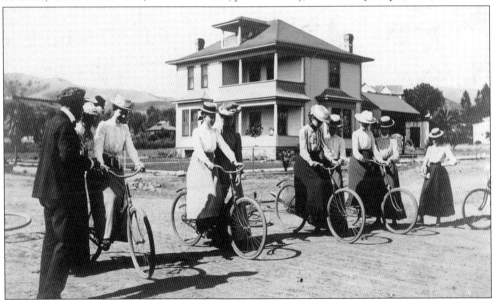

Female students queue up at the starting line of a bicycle race during Field Day in 1902, well before Painter Avenue was paved. The building in the background is currently on the site of the Ruth B. Shannon Center at the northeast corner of Painter Avenue and Philadelphia Street. (WC.)

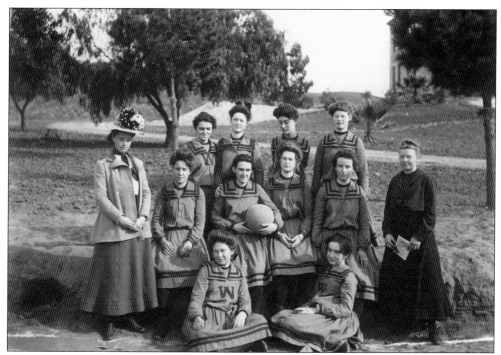

The women's basketball team of 1903 poses in uniform for a photographer. The student holding the ball is Anna Tomlinson, Whittier College's first librarian. She proudly wrote in a February 27, 1903, letter home that basketball was "quite the rage. We have a new court and hope to play a match game soon." At this time, before Tebbetts Gym was built, students played on an outdoor sand and gravel court. (WC.)

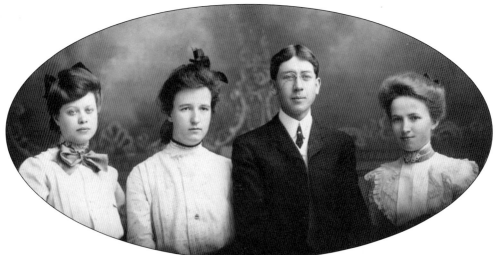

By 1904, Whittier College was established and had 25 students. It was state-accredited and graduated its first class of four seniors. The graduating students, from left to right, were Inez A. Greene, Edith Tebbetts, Theodore Smith, and Dell Coryell. Whittier's first commencement ceremony was attended by 1,000 people. Local shop owners even shuttered their stores during the event to attend. In order to accommodate such a large crowd, the ceremony was held outside under a circus tent propped up with lumber borrowed from a local mill. (WC.)

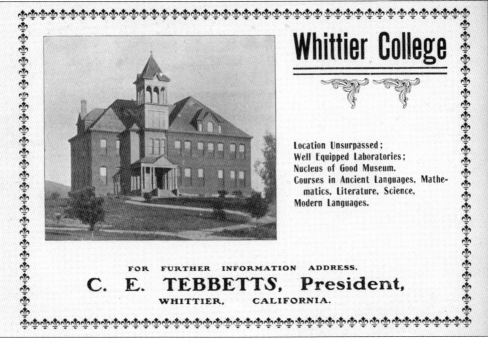

In 1904, Whittier College president Charles E. Tebbetts placed an ad in the new *Acropolis* literary review (later the college annual) to show off Founders Hall and some of the growing college's fields of study. Whittier College already offered majors and required 24 units and a thesis to graduate. (WC.)

"The Rock" has been a Whittier College symbol since 1912. That year, seniors Frank Crites, Nofle Renneker, and Milton White discovered the boulder on a hiking trip to the Sierra Madre Mountains. With the help of fellow graduate Austin Marshburn, they brought the immensely heavy granite rock back down to Whittier. Not to be outdone, the junior class buried The Rock that morning, and the seniors had to use a crane to unearth the boulder and encase it in concrete to prevent further burials. (WC.)

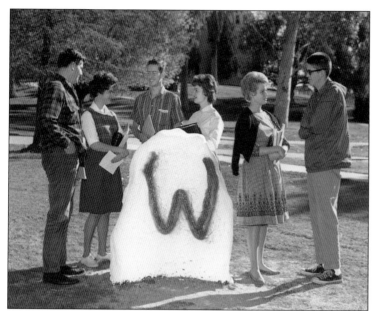

As tradition, The Rock has been consistently painted—at first for a whole semester, then twice a week, and now nearly every day. Well into the 1970s, students would set fire to The Rock to burn off the previous paint and ready it for a new design. (WC.)

Inspired by a tradition at Earlham College, librarian Anna Tomlinson (in the lower left corner) planned the College May Day festival, which was held annually from 1907 to 1919. The tradition included plays, refreshments, the winding of the maypole, and the ceremonial crowning of the "Queen of May." In this photograph taken on May 1, 1913, May Queen Vivian Rice (in the center, directly in front of the Whittier banner) was honored. (WC.)

In the 1920s, an arroyo intersected the campus; students crossed it via a series of bridges (like the one shown here) between Founders Hall and the Girls' Cottage. Five women, showcasing the fashion of the time, enjoy a picnic next to the arroyo. In the background are Wardman Hall (the Men's Dormitory at the time) and the newly constructed Wardman Gym (at right). (WC.)

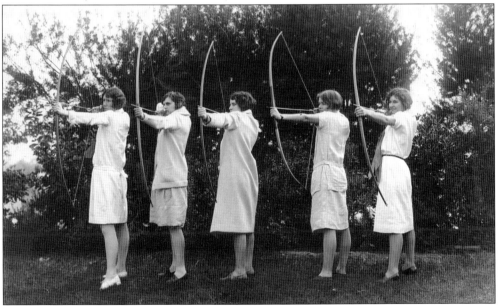

In 1920, assistant instructor Edith Logan helped organize the Women's Athletic Association on campus, which helped women's sports to be taken more seriously. In 1922, the first letter sweaters were given to the women Poets. The college even had an intercollegiate women's baseball team, which beat the University of Southern California team in their first game. The 1927 women's archery team is pictured here. From left to right are Esther Foster, Charlotte Keck, Marian Elliott, Ruth Price, and Melva Wildman. (WC.)

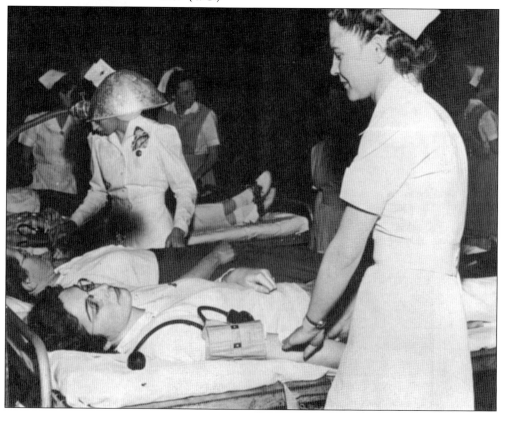

Thanks largely to local businessman Aubrey Wardman, Whittier College was able to gain stable financial footing in the 1920s. Even from the earliest days, the Wardmans played a role in the formation of the college. Aubrey and his wife, Bonnie, pulled a plow during construction of Founders Hall. In 1923, he donated $100,000 to build a new gym and men's dormitory, later named Wardman Gym and Wardman Hall, respectively. (WC.)

Whittier College's women played a vital role on campus during World War II. Their efforts included blood drives, a war bond booth, and USO dances. The spirit of the college during this time is reflected in the 1944 annual: "Students of 1944 . . . realizing the significance of the struggle they participated actively. Accepting responsibilities giving freely of themselves they became leaders, they gained a richer life." (WC.)

Due to significantly reduced enrollment, students from Chapman College moved to Whittier College for the duration of the war. Chapman undergraduates joined Whittier students, but the college maintained its own identity and student government and granted its own degrees. Meanwhile, from 1941 to 1945, the facilities on Chapman's campus were transformed to accommodate commercial and industrial ventures for the war effort. (WC.)

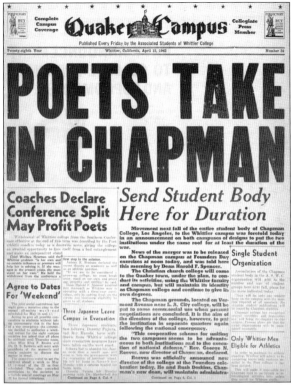

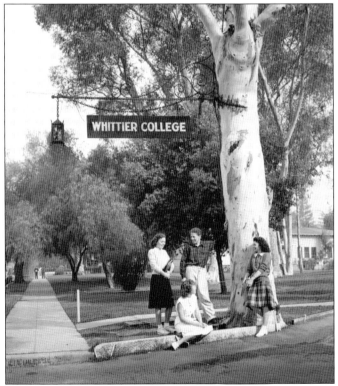

The postwar years saw a huge boom in enrollment at Whittier College. During the late 1940s, student population increased from a mere 426 students in 1945 to 1,313 students in 1949, when this photograph was taken. By the spring of 1947, there were 556 male students on campus—500 of whom were GIs. (WC.)

79

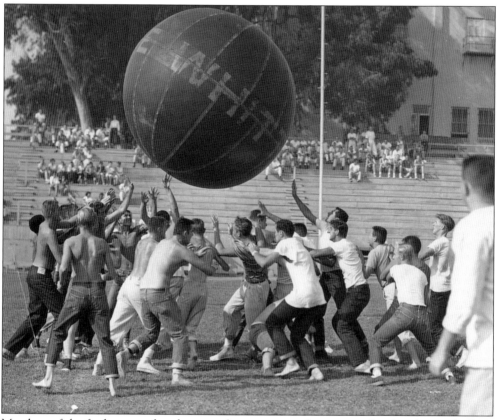

Members of the freshman and sophomore classes competed against each other for nearly three decades in pushball tournaments, held each year at Hadley Field and shown in this 1951 photograph. The contestants pushed a large inflatable ball across the field in order to score goals against their adversaries. The victor of the competition won bragging rights, and The Rock was then painted in their class's honor for an entire semester. (WC.)

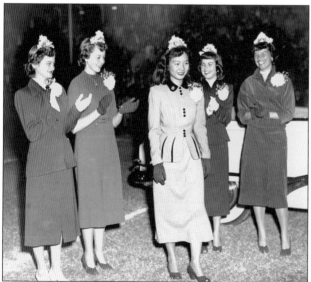

Homecoming at Whittier College was one of the most well-attended events of the year. College organizations and administration, as well as local groups, participated in a parade along Philadelphia Street. At halftime, the college crowned its homecoming royalty. Although the parade tradition has gone by the wayside, a queen and king are still crowned every year. Senior Carolyn Matsuda (center) accepts the crown as Homecoming Queen in this 1951 photograph. Her court consisted of, from left to right, Phyllis Lee, Sally Hockaday, Dee Fleck, and Jamie Brown. (WC.)

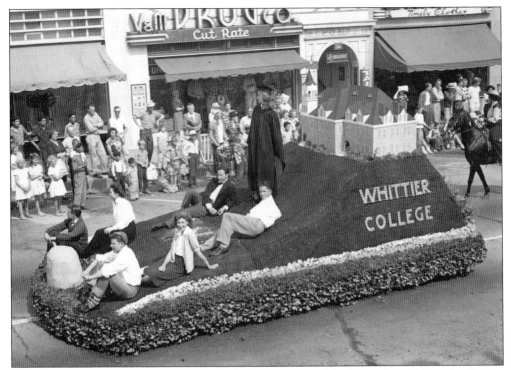

A float from the 1947 homecoming parade features a model of Founders Hall and a "living recapitulation" of the path from the first year through matriculation. A graduate stands in regalia at the top of a hill, and representatives from the freshman, sophomore, and junior classes are in various states of repose in front of her. A papier-mâché model of The Rock is prominently featured at the front of the float. The student closest to The Rock is wearing the typical freshman cap. In those days, tradition held that freshman students should wear these emerald-colored caps to signify them as the "greenest" students on campus. (WC.)

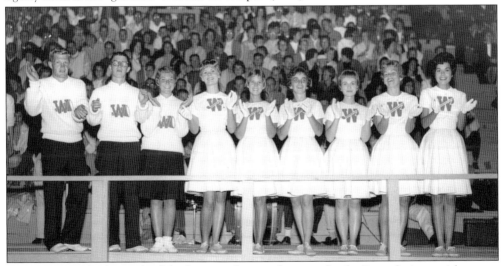

The 1962 cheerleaders and yell leaders join the crowd to root for the Poets during a night game. From left to right are Woody May, Joe Curtis, Lynn English, Vickie Ekdahl, Gail Wright, Shelly Wood, Pattie Carlson, Sue Jones, and Leana Peck. (WC.)

81

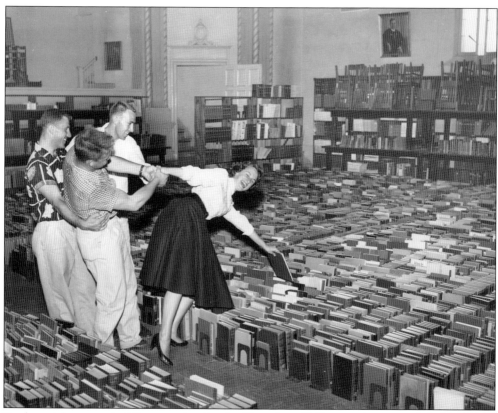

Students joke around while preparing for the library's c. 1961 move from a modified ballroom in Mendenhall to the college's fourth library iteration at the newly constructed Bonnie Bell Wardman Library. Wardman Library was inducted in 1965 with a speech by Richard Nixon, who highlighted the importance of this new structure as a symbol of the college's commitment to learning in the 20th century. (WC.)

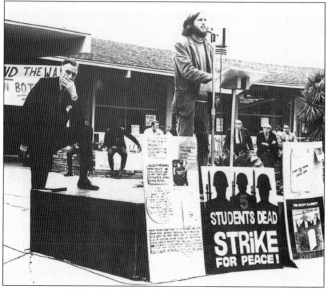

The 1960s were a time of protest on campus. Whittier College officially condemned the Vietnam War, as at the protest rally pictured here, and the civil rights movement took hold of the student population. In 1969, the newly created Black Student Union penned a list of five demands, which included more representation on campus. And in 1968, alumnus Martin Ortiz opened the Center of Mexican American Affairs to assist the growing Hispanic population on campus. (WC.)

Five

INTERWAR URBANIZATION AND GROWTH
1918–1939

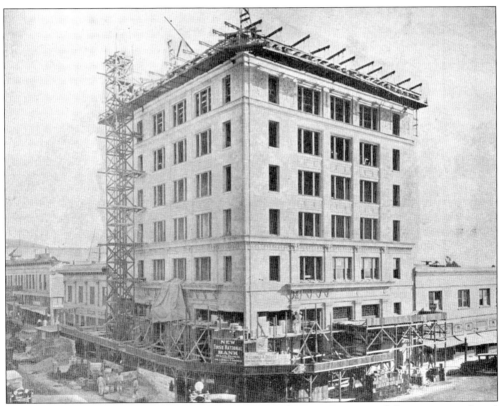

The interwar years saw a surge in development as Whittier transitioned from an agricultural economy to one based in manufacturing and service. Chief among new developments was the six-story First National Bank building constructed in 1923. Still arguably Whittier's most well-known structure, the Beaux Arts skyscraper housed Richard Nixon's first law office and was designed by John and Donald Parkinson—the same architects who designed Los Angeles's Union Station, Memorial Coliseum, and City Hall. (WPL.)

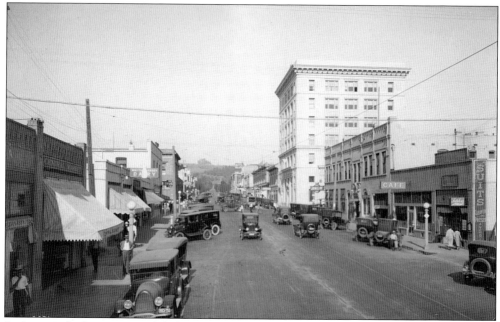

In this view looking east up Philadelphia Street in 1924, the new First National Bank rises above Greenleaf Avenue intersection while the also newly constructed William Penn Hotel looms farther up the street. Note the absence of the Pacific Electric tracks. Although the line initially ran up Philadelphia Street and turned south on Greenleaf Avenue, after automobiles became more common in the business district, the terminus was moved back to Philadelphia Street and Comstock Avenue. (WPL.)

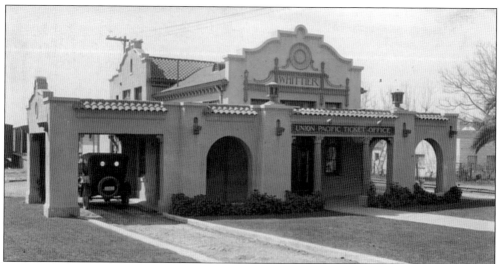

Farther south on Philadelphia Street, near the intersection of what is now the Greenway Trail, the Union Pacific ticket office opened for business in 1918. Passenger service ceased in 1931, when the building became a bus depot. The Mission Revival style of the structure reflected a changing architectural aesthetic in Southern California that shaped the facades of many new houses in Whittier in the 1920s and early 1930s. (WPL.)

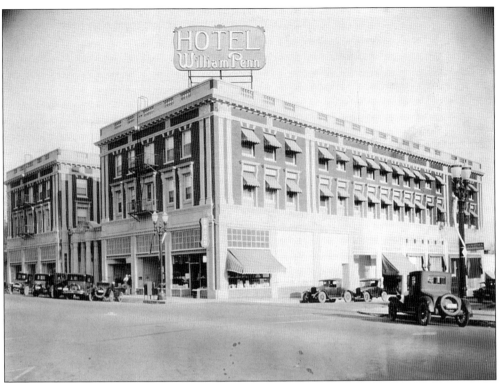

In a 1924 special supplement to the *Whittier News*, boosters pointed to the newly constructed William Penn Hotel (on the southeast corner of Philadelphia Street and Washington Avenue) as evidence of "the general advancement of the city of Whittier." The hotel was damaged by a fire in 1979 and demolished in 1981. (WPL.)

Whittier Home Telephone Company founder, oil investor, citrus grower, philanthropist, and Whittier College benefactor Aubrey Wardman built the Hoover Hotel in 1930. Named after Whittier resident (and, later, First Lady) Lou Henry Hoover, the hotel's construction and operation provided jobs for Whittierites during the Depression. The Spanish Colonial Revival structure on south Greenleaf Avenue was the most upmarket place to stay in midcentury Whittier and is still in use today as senior apartments. (WM.)

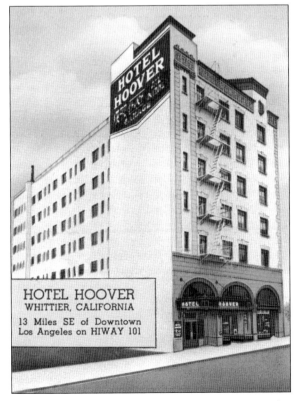

HOTEL HOOVER
WHITTIER, CALIFORNIA
13 Miles SE of Downtown
Los Angeles on HIWAY 101

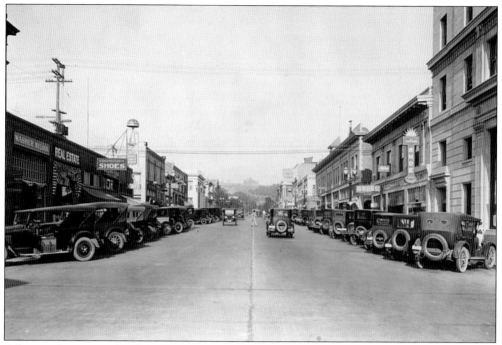

A lone pedestrian makes her way across Philadelphia in this late-1920s street-level photograph. Like previous pictures, this one, which looks east up Philadelphia Street from the intersection at Greenleaf Avenue, shows how car culture had permeated daily life in uptown Whittier by this time. (WPL.)

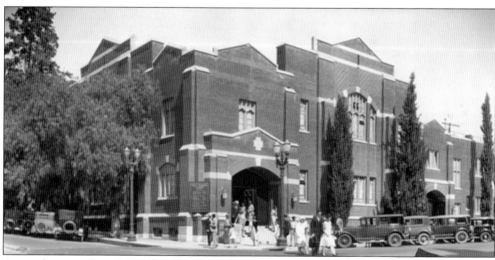

Across the street from the William Penn Hotel on the northeast corner of Washington Avenue and Philadelphia Street, this brick First Friends Church meetinghouse, built in 1917, was the Quaker congregation's third (and the second built at this location). After this building was condemned in 1969, when it was determined that it would likely fail in the event of an earthquake, the church constructed a new meetinghouse in 1973; it is still in use. (WPL.)

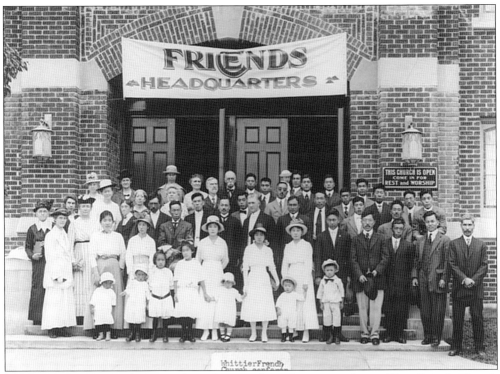

Japanese American Quakers pose for a photograph on the steps in front of First Friends Church at a 1922 California Yearly Meeting. (Los Angeles Public Library.)

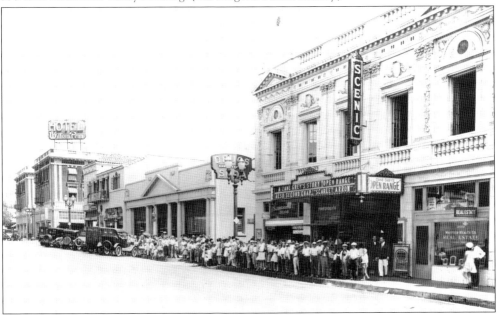

People—mostly youngsters—line up to see the 1927 blockbuster *Open Range* at the Scenic Theater (later renamed the Roxy) at the southeast corner of Philadelphia Street and Bright Avenue. The William Penn Hotel is visible, as is the neoclassical Southern Counties Gas Company building directly east of the Scenic Theater. (WM.)

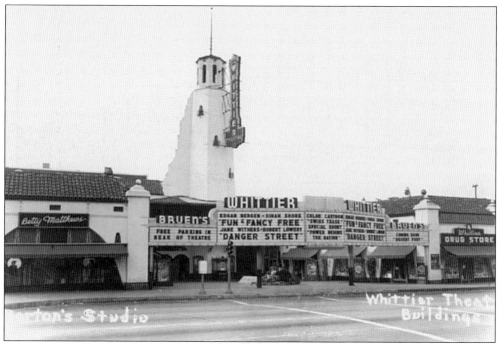

On the eve of the Great Depression, there were several theaters in Whittier, including the Scenic Theater on Philadelphia Street and Wardman Theater (previously the Optic) on Greenleaf Avenue, as well as the newly built McNees Theater (later Bruen's Whittier Theater, as shown in this 1947 photograph) at Whittier Boulevard and Hadley Street. After opening in the summer of 1929, the atmospheric theater stood for 91 years but was badly damaged in the 1987 Whittier Narrows earthquake. Despite preservation efforts, it was finally demolished in 1990. (WPL.)

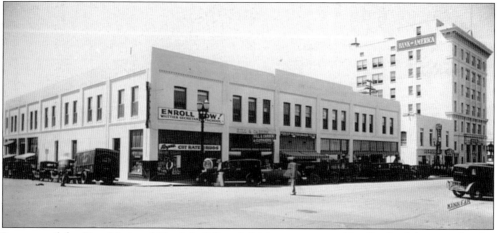

Just east of the First National Bank building (which was occupied by Bank of America by the time this c. 1930 photograph was taken), the Emporium Building was located at the southwest corner of Philadelphia Street and Bright Avenue. The two-story structure was home to various businesses over the years—including the Whittier Secretarial School, Roger's Drug Store, Hill & Garden Clothiers, and Whittier Grocery—before it was irrevocably damaged in the 1987 Whittier Narrows earthquake and demolished just two days later. (WPL.)

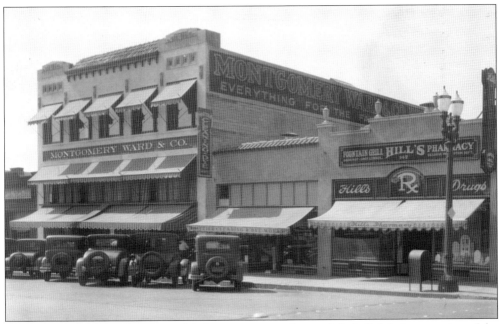

Though the facade has been remodeled, visitors can still see a faded, slightly later version of the painted "Montgomery Ward" sign on the side of the building (pictured here around 1930) that the store once occupied at the southwest corner of Greenleaf Avenue and Bailey Street. (WPL.)

Whittier's police, including two motorcycle officers, pose near their headquarters behind the new city hall in this 1923 photograph. Reorganized that year by new chief and former Whittier State School security head I.B. English, the department was on call for 24 hours for the first time. Two years later, Whittier's police got a new headquarters and jail facility next to city hall on Bailey Street. (WPL.)

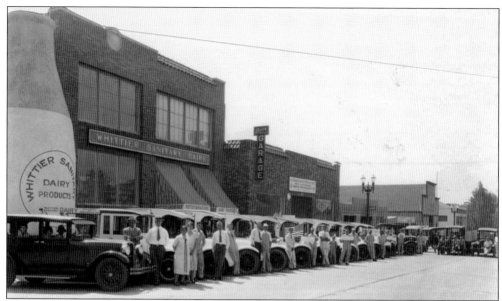

The Whittier Sanitary Dairy was located at 130 South Comstock Avenue, just below Philadelphia Street. When this 1925 photograph was taken, the dairy was better outfitted (with automobiles) than the city's police department; however, during the interwar period, Whittier's residents arguably needed milk, cream, butter, and cheese more than police protection. (WPL.)

In the interwar period, more cars and trucks necessitated more oil and gasoline, and by 1930, Whittier service stations abounded. In this 1933 photograph, four unidentified station attendants at the Union Oil Station on Hadley Street and Comstock Avenue take a break from pumping gas to pose. Though the job was sometimes dirty, in the 1920s and 1930s, service station attendants often wore all white. (University of Southern California.)

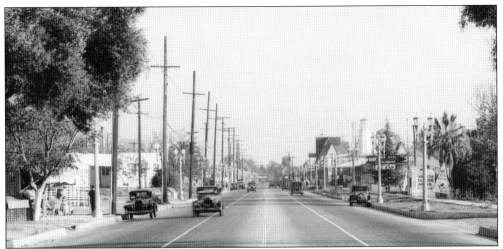

Writing for the Automobile Club of Southern California in 1924, Gerald W. Ritchie noted, "To Whittier . . . the automobile is not only a means of commercial transportation but a recreational and social medium which is simply indispensable." Automobiles putter along Whittier Boulevard in this 1933 photograph taken just west of Hadley Street. Note the tower of the Whittier Theater and "beer on tap" at the edge of the proudly dry town. (University of Southern California.)

Between the wars, the city was urbanizing, especially near its center, but parts of Whittier remained rural well into the 1950s and 1960s. Although we do not know the name of the "dairy queen" pictured here, the c. 1935 photograph was almost certainly taken at the Pellissier Dairy on Workman Mill Road, and the Holstein cow was very likely one of Pellissier's prizewinning heifers. (Los Angeles Public Library.)

The 18-acre Whittier Heights Memorial Park opened southwest of the Pellissier Ranch in 1918. This 1930 photograph affords the first instance of the famous hilltop sign (in the background at far right) bearing the park's new name—Rose Hills—though, for some reason, it lacks the terminal "S." By midcentury, expansion projects reshaped surrounding hillsides and significantly enlarged the site. At 1,400 acres, Rose Hills remains the largest cemetery in North America. (University of Southern California.)

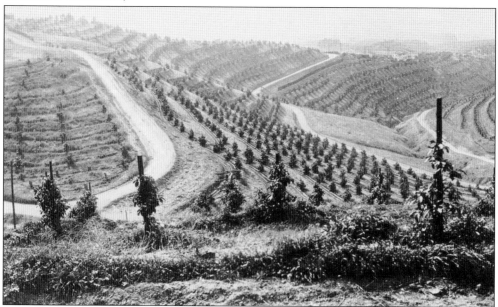

Though fewer in number, walnut and citrus groves remained a common sight in and around Whittier in the 1920s and 1930s; however, another crop—avocado—was burgeoning. Horticulturalist Albert Rideout introduced avocados to Whittier in the early 1900s and planted seedling avocados on the terraced hillsides of Rideout Heights after he purchased this land in 1910. (University of Southern California.)

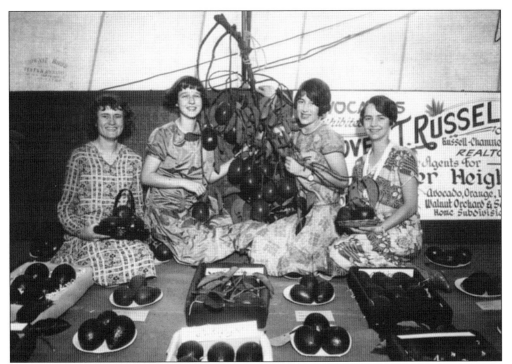

By the mid-1920s, Whittier was well known as a top avocado-producing region and a place that had a hand in breeding several renowned cultivars, including the Ganter and Hass varieties. In 1925, the city began hosting annual "Avocado Shows" to showcase the famous fruit. Sponsored by the Progress Club and featuring games, rides, food, entertainment, exhibits, and the crowning of an "Avocado Queen," these weeklong fairs attracted thousands of attendees each May. These photographs are from the eighth annual show, which was held at the Whittier Laundry Baseball Park at the corner of Hadley Street and Magnolia Avenue in 1933. (Both, Los Angeles Public Library.)

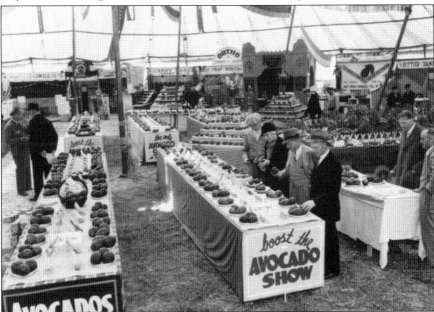

Whittier's population nearly doubled in the 1920s—from 7,997 (in 1920) to 14,822 (in 1930). The increase was a boon to homebuilders, who vied for new residents' business (as shown in the above *Whittier News* advertisement from 1924), and to realtors and developers, who began to subdivide existing citrus and walnut orchards—a practice that would be repeated on a much greater scale in postwar Whittier. Lots in one of the city's first subdivisions, College Hills, were first offered for sale in the late 1920s. The contemporary brochure features bungalows, typical of the time, as well as Mission Revival and Mediterranean homes, which became increasingly popular in the 1920s and 1930s. (Above, WPL; below, WM.)

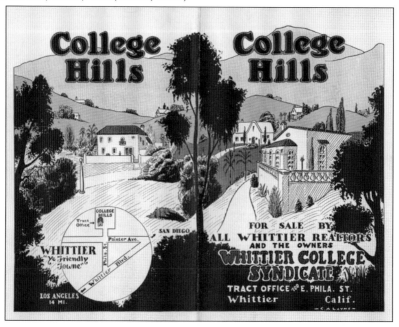

Though far more luxurious than the majority of new houses constructed at the time, Wardman House is an excellent example of a Whittier home that incorporates both Mediterranean and Mission Revival elements. It was built high atop Summit Drive in 1926 for Whittier businessman and college benefactor Aubrey Wardman and his wife, Bonnie Bell. After their only son died in 1943, the Wardmans deeded the mansion to Whittier College. (WPL.)

Whittier College took possession of Wardman House in 1966, upon the death of Bonnie Bell, and it has served as the residence for the school's presidents ever since. However, the Wardmans used their home to benefit Whittier College from the first. In this c. 1930 photograph, a group of Whittier coeds gathered on Wardman House's central patio turn away from a second-to-none view of south Whittier to pose for the photographer. (WC.)

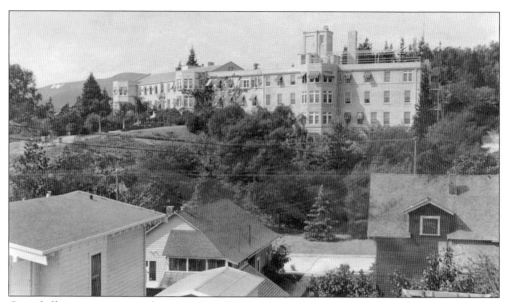

On a hill across town, at the top of Hadley Street and the edge of Alta Park, was another philanthropist-backed structure. Built in 1921 by Simon Murphy Jr. as a memorial to his father, Murphy Memorial Hospital served as Whittier's main hospital for nearly four decades. Shortly after its construction, proud Whittier boosters noted, "Today, no city on the Pacific Coast has a more modern hospital building or equipment." (WPL.)

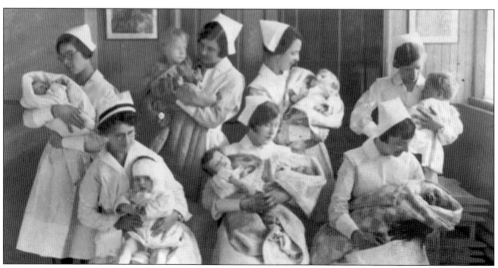

In addition to its modern operating room, electric sterilizers, clinical lab, and x-ray and electrocardiograph machines, Murphy Memorial Hospital also boasted a 10-bed maternity wing to accommodate—and help deliver—Whittier's growing population. (WM.)

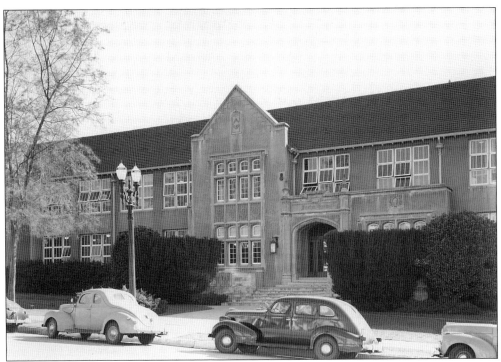

Whittier's increasing population required the building of additional civic and municipal buildings, although in some cases, additional sites were modified. In 1926, a new Jonathan Bailey School was constructed. Whereas the old, wooden schoolhouse had faced Bailey Street, the new brick and concrete structure faced Hadley Street, on the other side of campus. (WM.)

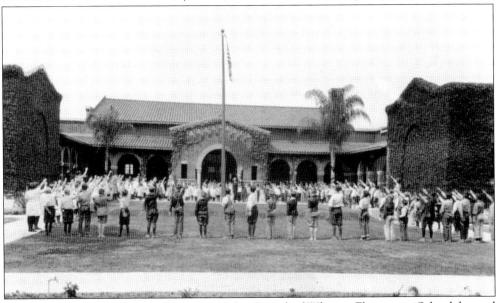

Students recite the Pledge of Allegiance at John Greenleaf Whittier Elementary School, located on Whittier Avenue, in the late 1930s. Because of the similarity to the Nazi salute, Congress amended the Flag Code and replaced the Bellamy salute (named after the author of the pledge, Francis Bellamy) with the more familiar hand-over-heart salute in 1942. (WPL.)

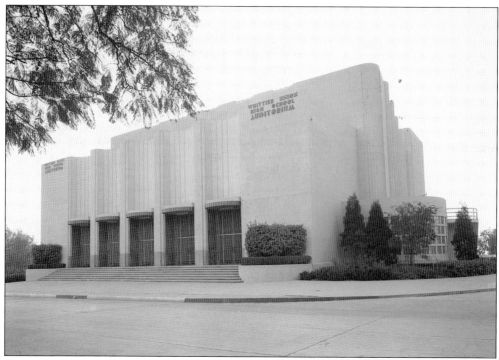

Opened in 1940 to replace the auditorium damaged in the 1933 Long Beach earthquake, the 2,448-seat Art Deco auditorium was among several structures built by the Works Progress Administration (WPA) at Whittier High School beginning in 1938. (Barton's Studio, WPL.)

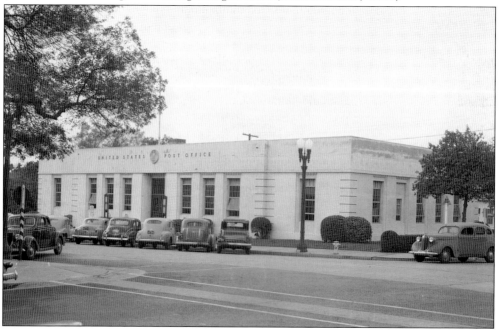

As evidenced by stamps in sidewalks around Whittier, the WPA had a hand in more than a few improvement projects in the 1930s and early 1940s, including the Moderne-style Washington Avenue post office designed by renowned New Deal architect Louis A. Simon. (Barton's Studio, WPL.)

In 1932, the Whittier National Trust and Savings Bank got a Moderne redesign. The new building, designed by Whittier architect William Harrison, replaced the institution's brick building that had stood on the northeast corner of Greenleaf Avenue and Philadelphia Street since 1905. (WM.)

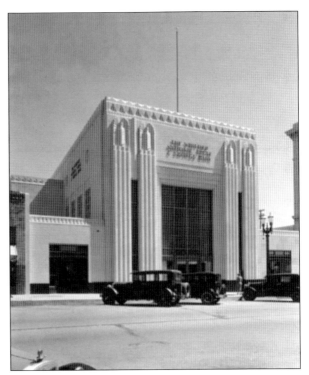

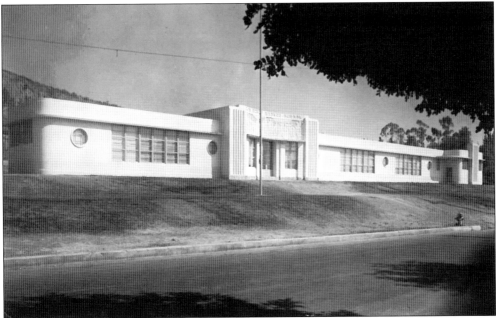

Designed in 1938 by William Harrison and named after a famous Whittier resident (and First Lady), Lou Henry Hoover Elementary School, located on Alta Avenue and Camilla Street, is a fine example of WPA Moderne architecture. The frieze above the school entrance depicts Whittier's Quaker founders, and a quote by Von Humboldt before the front staircase (yet unbuilt in this photograph) is well-remembered by all who visit: "What you would want in the life of a nation you must first put into its schools." (Whittier City School District.)

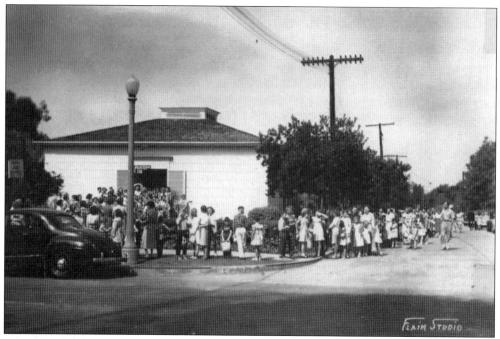

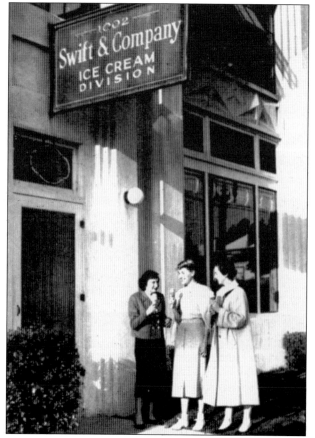

Whittier architect William Harrison lent his expertise to help design this humble but important structure. The Whittier Art Association Gallery, located on Painter Avenue and Mooreland Drive, was built in 1939 to advance the appreciation of community art via classes, workshops, and exhibitions. The venerable institution is still in operation in its original location, and the structure has remained largely unchanged. (WM.)

Easily one of Whittier's most striking structures, the former Whittier Ice Cream Company building, constructed on the northeast corner of Hadley Street and Hoover Avenue in 1930, offers another striking example of the Art Deco/ Moderne style. At midcentury, the Swift & Company ice cream division occupied the space, and a small door that opened onto Hadley Street led into a popular ice cream parlor and soda fountain. (WM.)

Just before World War II, Moderne buildings abounded. The impressive First Christian Church had risen across the street, and the catty-cornered Harvey Apartments had an Italianate facelift, but the Lindley Building—one of the original Four Bricks—remained unaltered. Hazlitt's Grocery occupied the space from 1923 until 1967. The building required demolition after the 1987 earthquake, but its 1990s replacement—a replica—incorporated bricks from the original structure. (WPL.)

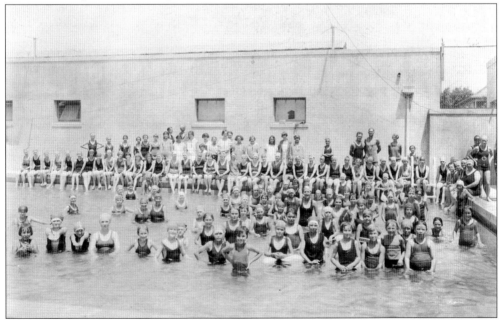

The YMCA was a prominent community organization in Whittier from its earliest days, touted by boosters in the 1920s as an example of the city's social and recreational opportunities. Although it did not have its own building and pool until 1948, the Y administered the community swimming pool at Whittier High School beginning in the early 1920s, giving thousands of inexpensive lessons to Whittierites of all ages during summers between the wars. (WM.)

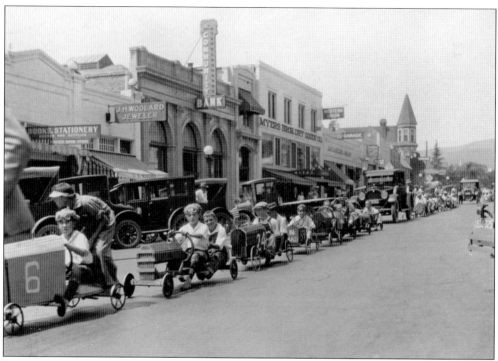

Beginning in 1921 and sponsored by the Whittier Lions Club (and later the Elks, too), "coaster races" were annual events in Whittier between the wars. Courses winded along paved streets closed for the occasion and changed every year. They took advantage of Whittier's steep geography, just like the hill climbs sponsored by motorists earlier in the century. At their height, the events included nearly 100 participants in categories based on age, with prizes awarded to the fastest racers. In these 1926 photographs, competitors parade along Greenleaf Avenue (above) before posing at the start of the race at the top of Pickering Avenue (below). (Both, WM.)

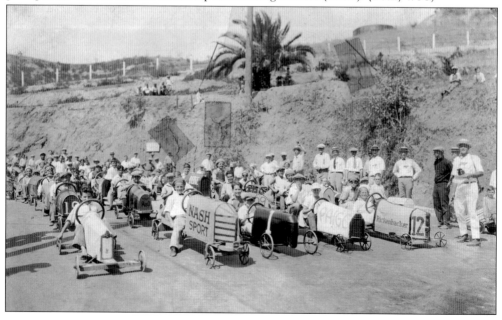

Six

INTERLUDE
RICHARD MILHOUS NIXON

Although Richard Milhous Nixon was born on January 9, 1913, in Yorba Linda, California, he is without a doubt Whittier's most famous son. Following his election to the presidency in 1968, official "Welcome to Whittier" signs posted at the city limits included the line "Hometown of President Nixon." (Lee Idaho.)

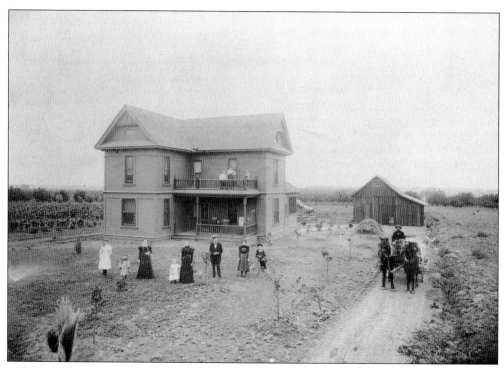

Richard was the second of five Nixon boys, including Harold (1909), Francis Donald (1915), Arthur (1918), and Edward (1930). He was from a large, tight-knit Quaker family—the Milhous family—that was well established in Whittier. This photograph of the Milhous family homestead in Whittier was taken in the 1890s. (WC.)

Richard's parents, Francis (Frank) Nixon and Hannah Milhous, met at a Valentine's Day party in 1908, soon after Frank arrived in Whittier. After four months of dating, the newlyweds moved to Yorba Linda, where Frank built their house from a Sears kit. Hannah's father gifted the couple citrus trees to plant at their new home; however, their farming was unsuccessful, and they decided to move back to Whittier. This photograph was taken on their wedding day in 1908. (WC.)

The Nixons experienced much heartbreak in their family history. Their son Arthur died of encephalitis (tuberculous meningitis) in 1925 at the young age of seven. Richard often declared that Arthur's death was one of the most challenging times of his life. Unfortunately, this was not the end of the familial tragedies. In 1933, after a long bout with tuberculosis, the Nixons' vivacious son Harold died at 24. For Richard, these tribulations forced him to become a fighter. This photograph is of the Nixon boys. From left to right are Harold, Richard, Arthur, and Donald. (WC.)

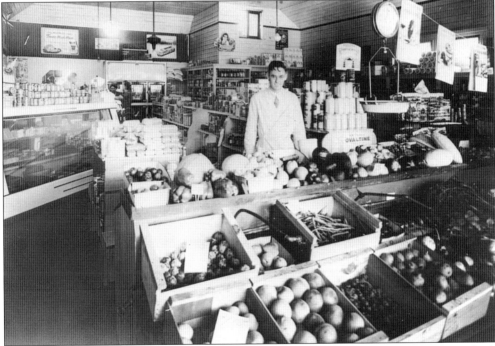

When the Nixons moved to Whittier, they opened a service station, Nixon's Service, which became a family institution. All members of the family pitched in. Hannah baked pies and cakes to sell, and young Richard woke at 4:30 a.m. every day to drive to Los Angeles with his father to pick out vegetables for their market. Each day after school, Richard would return to the store to take inventory and spray for flies. This photograph shows the interior of the store, where family member George Brickles is showing off the day's produce. (WC.)

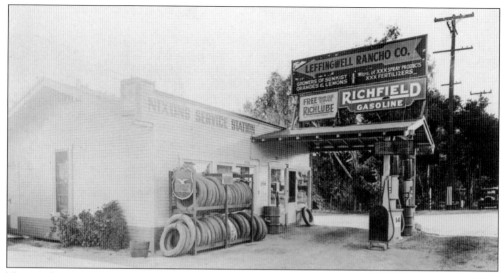

Nixon's Service Station, located on Whittier Boulevard, was run by the family for many years. This picture was taken on December 10, 1931. (WC.)

Upon graduation from Whittier High School, Richard received the coveted "Best All Round Student" award from the Harvard Club of California. As was customary, upon winning the prize, he was awarded a scholarship to Harvard University. With this prize, he would only pay out of pocket for living expenses and his travel to and from the university. However, since the family was strapped for cash after the Depression, losses at the store, and medical expenses due to Harold's illness, Richard decided to attend Whittier College. This photograph shows Richard (far left, second row) during his senior year with fellow Whittier High athletics managers. (WC.)

During high school, Richard participated in the Constitution Orator's Club. This 1929 photograph of the club includes Richard (second row, third from left). During his time with the club, Richard won first place for his speech entitled, "Our Privileges Under the Constitution." (WC.)

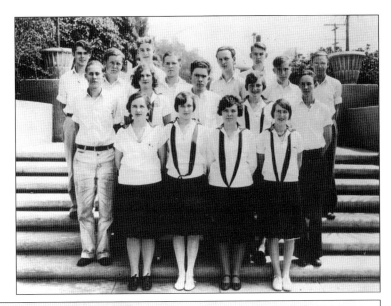

1932 ACROPOLIS

SWEENEY WATSON NIXON MILLER

Forensics

Richard was an integral part of Whittier College's debate team for all four years of college. The team participated in challenges across the country, which allowed Richard—who otherwise could not afford it—to travel. During his debates, he argued on topics including war debt and the Constitution. At the time, members of the debate team were seen as leaders of the campus and were often reviewed on the front page of the student newspaper. (WC.)

Richard, admitted benchwarmer, gained the respect of coach Wallace "Chief" Newman and the football team through his passion, dedication, and enthusiasm. Throughout his life, Richard (wearing the no. 12 jersey in this photograph) often referred to Chief as one of the most influential men in his life. Chief taught his team to never give up, and that failure was not an option. This photograph was taken in 1932, Richard's junior year. (WC.)

During his campaign for president of the Whittier College student body, Richard's central issue was that of school dances. For years, dances were outlawed on campus—a strict dictum handed down from the Quaker days of the college. Although not a fan of dancing himself, he was able to talk the board into allowing school dances to be held in the gym on the argument that students could be supervised (unlike when they went into the city to dance), the school could charge admission, and the students would be safe. In this page from the annual of his senior year, Richard is described as the reason for Whittier's success. He was a fearless leader—"always progressive, and with a liberal attitude." (WC.)

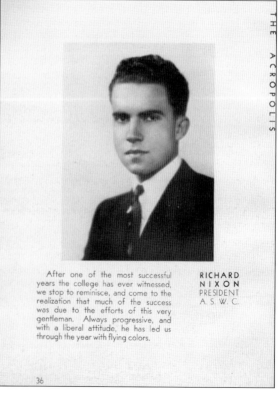

THE ACROPOLIS

After one of the most successful years the college has ever witnessed, we stop to reminisce, and come to the realization that much of the success was due to the efforts of this very gentleman. Always progressive, and with a liberal attitude, he has led us through the year with flying colors.

RICHARD NIXON
PRESIDENT
A. S. W. C.

36

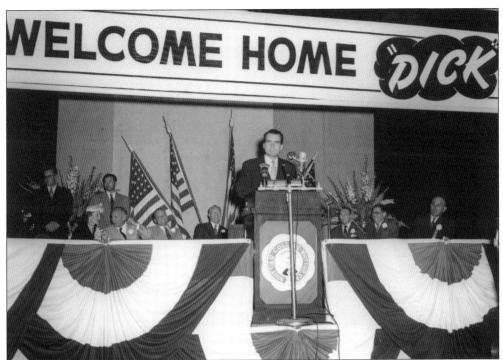

On August 8, 1952, Sen. Richard Nixon attended a rally in his honor at Whittier College. The rally was held on Hadley Field, and nearly 15,000 fans packed the stadium. In July of the same year, Nixon was named the vice presidential candidate for Dwight D. Eisenhower. Above, Nixon stands on stage below a banner reading "Welcome Home 'Dick.'" To the left are his proud parents, and to the right, his proud mentors Paul Smith and Wallace "Chief" Newman. Below, Richard and his daughter, Tricia, ride in a Cadillac convertible east up Philadelphia Street past the Eisenhower-Nixon campaign center between Friends and Painter Avenues. (Both, WC.)

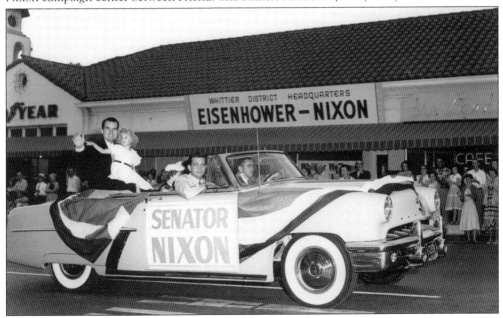

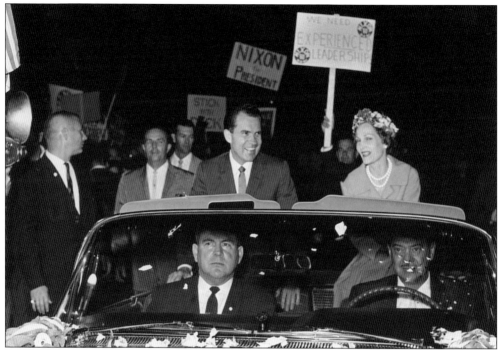

Richard Nixon met Patricia "Pat" Ryan on January 16, 1938, and declared that day that he would one day marry her. They met while acting in a local amateur theater's production of *The Dark Tower*. Pat was then a 26-year-old teacher who ignored Richard's advances for some time. He eventually won her over, and they were married on June 21, 1940, in a small, nonreligious ceremony at the Mission Inn in Riverside. This photograph is of the couple in Whittier during Richard's presidential campaign. (WC.)

From his first election—for president of Whittier Union High School's Student Council—to his presidential run, Richard remained faithful to his hometown, even inviting his Whittier College history professor, Dr. Paul Smith, to sit with his family at his inauguration in 1969. In this picture from that day, Whittier High School cheerleaders stand proudly in front of the Capitol in Washington, DC, to honor the class of 1930 alumnus. (WC.)

Seven

MIDCENTURY
DEVELOPMENT
AND EXPANSION
1939–1967

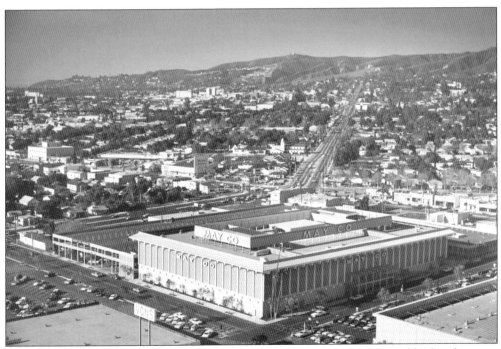

In the decades following World War II, Whittier's population surged. New neighborhoods sprang up where citrus, avocado, and walnut groves had once thrived. The city's boundaries (and services) expanded, and new areas, including east and south Whittier, were annexed. The rise of car culture shaped the progress and character of each area of development. (WM.)

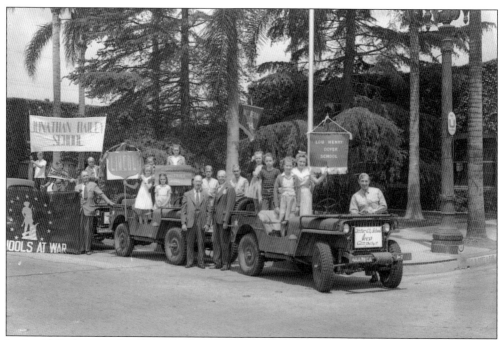

In this 1943 photograph, taken outside city hall, Whittier City School representatives fly banners atop a three-car parade of newly introduced jeeps as part of the Schools at War Program's national jeep campaign bond drive. In 1943, in just two months, Southern Californian students—like these young Whittierites—scrimped and saved, ultimately investing $6.5 million in war bonds and stamps, enough to purchase 3,215 of the military utility vehicles. (Whittier City School District.)

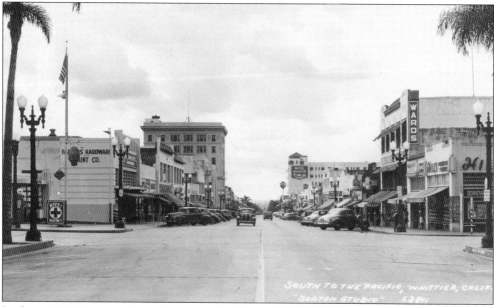

In this c. 1945 photograph, an American Red Cross sign (at far left) at the Shell station on the southeast corner of Bailey Street and Greenleaf Avenue implores potential donors to "Give! Now!" to help the war relief effort. The parking meters on both sides of Greenleaf Avenue were removed by the city in the late 1970s in an effort to revitalize the Uptown area. (Barton's Studio, WPL.)

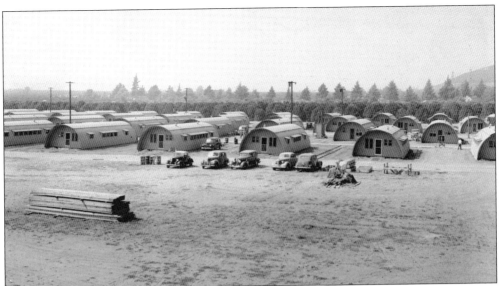

A postwar housing shortage in Whittier necessitated the construction of 34 surplus Quonset huts in Palm Park for returning GIs and their families. Although there was opposition to the Quonset village from residents worried about how it might negatively affect property values, the Whittier City Council unanimously approved the temporary structures, which were occupied from June 1946 until the early 1950s, when more permanent housing in Whittier became available. (WC.)

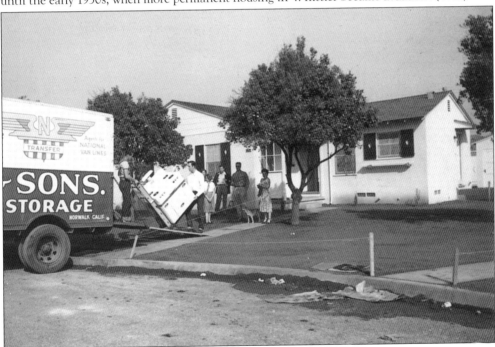

In the 1950s and 1960s, Whittier citrus, walnut, and avocado groves gave way to new streets, apartment buildings, and homes as ranchers sold their land to developers looking to cash in on the postwar housing demand. In this 1949 photograph, the Hansen family watches movers deliver a stove to their newly constructed home on Dicky Street; they stand in the shade of orange trees that were part of an orchard only a few months before. (Karen Hansen Alvarado.)

After the deprivations they endured during World War II, Whittierites were eager to get back to business as usual, including shopping, as demonstrated in this 1952 photograph of Tibbetts department store at Greenleaf Avenue just south of Philadelphia Street. (WC.)

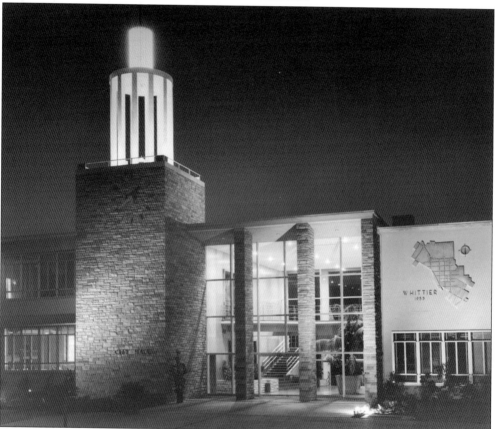

The postwar population increase and subsequent expansion of city government meant that by the early 1950s, it was clear Whittier needed new city offices. In 1955, city hall moved a third time—from the space it had occupied for three decades at Bailey Street and Greenleaf Avenue—to a new midcentury modern building, which would become the city's new civic center, on a block acquired by the city in 1953 and bounded by Painter and Washington Avenues and Penn and Mar Vista Streets. (WM.)

A library was one of several municipal buildings constructed at the new civic center. The new midcentury modern structure was far larger and better equipped than the 1907 Carnegie Library at Bailey Street and Greenleaf Avenue, and its construction spelled doom for the older library. Regarded by some as an antiquated relic, Whittier's Carnegie Library was demolished in 1955. (Julius Shulman, WPL.)

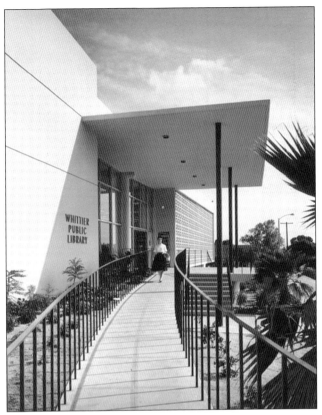

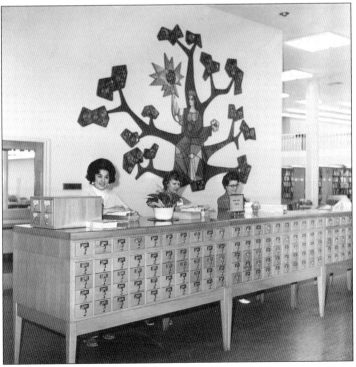

Just past the Washington Street entrance and around the corner from the circulation desk, reference librarians pose with a tool of their trade—the card catalog—in this 1960 photograph. The enamel and copper architectural mural behind them, *The Tree of Life*, was designed and created by Jackson and Ellmarie Woolley. Though the Whittier Public Library switched from a card to an online catalog in the 1990s, the sculpture remains. (WPL.)

In the 1950s and 1960s, service organizations regularly cleaned up the increasingly decrepit abandoned cemeteries that Willet Dorland founded at Citrus Avenue and Broadway in the late 1880s. By the mid-1960s, many remains had been relocated, but a sweeping change occurred in 1967 with the Whittier City Council's passage of Resolution No. 4021, which effectively removed the cemeteries. Headstones were dug out, and the grounds became what is now Founders Park. (WPL.)

A Whittier institution, Jack's Whittier Restaurant, first opened in 1933, followed by three other restaurants—Jack's Uptown, Jack's Beverly Fountain at El Mercado (a shopping center at Norwalk and Beverly Boulevards), and Jack's Salad Bowl (on west Whittier Boulevard). Though all were popular dinner destinations and high school and college hangouts in the midcentury, today only the original Jack's remains. (WC.)

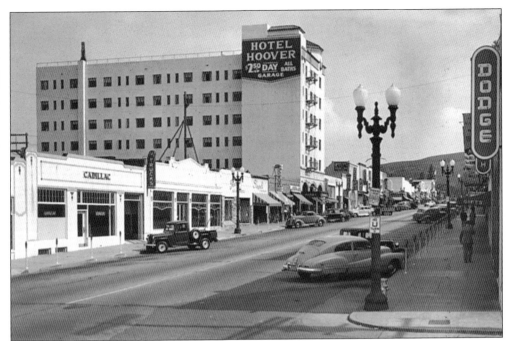

By the late 1940s, several car dealerships emerged on south Greenleaf Avenue, as shown in the 1946 photograph (above) taken at the corner of College (now Wardman) Street. In the 1950s, dealerships like Harris Oldsmobile (below) moved to Whittier Boulevard and into new, Googie-style buildings that reflected the aspirations and aesthetics of the Space Age. (Both, WPL.)

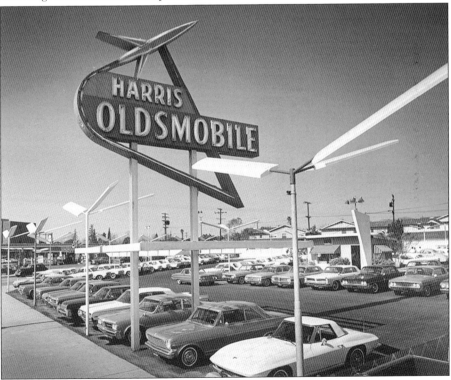

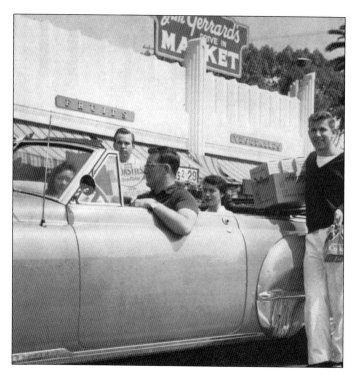

The sharp postwar increase in automobile ownership shaped the landscape and development of Whittier, and in the 1950s and 1960s, multiple businesses materialized that catered to car-driving patrons. In this 1952 photograph, Whittier College students idle their jalopy outside Jim Gerrard's drive-in market at the southwest corner of Painter Avenue and Philadelphia Street. (WC.)

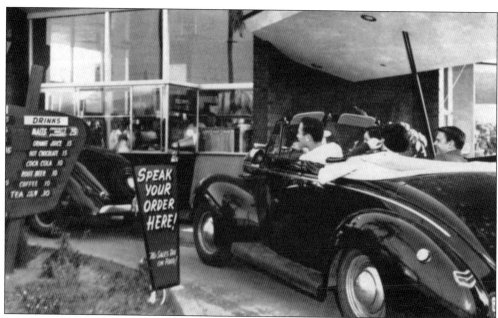

Another group from the college places an order at (Donald) Nixon's Drive-Thru Restaurant at 822 East Whittier Boulevard. (WC.)

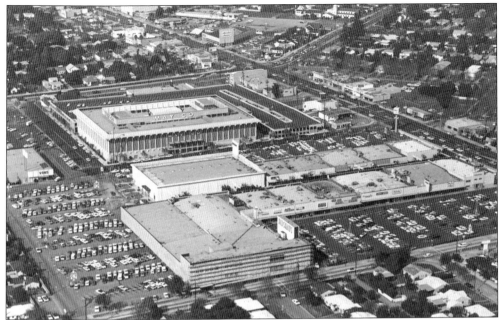

In the automobile-centric suburban landscape of the early 1950s, developers and city governments favored locating shopping centers on town edges to meet more specialized demands of consumers; Whittier was no exception. The "Quad" at Painter Avenue and Whittier Boulevard opened in 1953, followed by Whittwood Mall in east Whittier in 1955. Several established Uptown shops relocated to one center or the other. The upshot of these moves, in conjunction with the draw of the new shopping centers, was that the Uptown commercial district experienced a steady decline in business in the 1950s and 1960s. (Both, WM.)

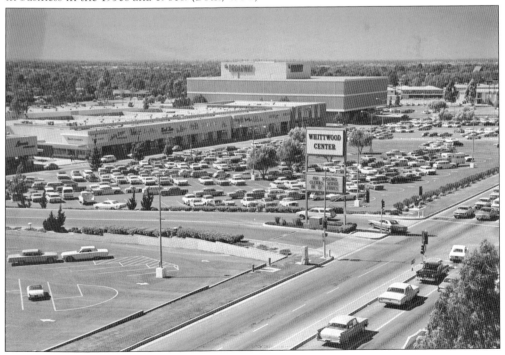

Another consequence of suburbanization in postwar Whittier was the rise of self-serve supermarkets, like the locally owned Box Market, and larger chains like King Cole, Safeway, and Alpha Beta. For residents—such as the Hansons (pictured at left)—who lived in the new homes and apartments of Whittier's postwar subdivisions, supermarkets were convenient, one-stop shopping locations with wider selection, lower prices, and far more free parking than smaller grocery stores in uptown Whittier, many of which closed in the 1960s and 1970s as a result of the new competition. (Left, WPL; below, Julius Shulman, Getty Images.)

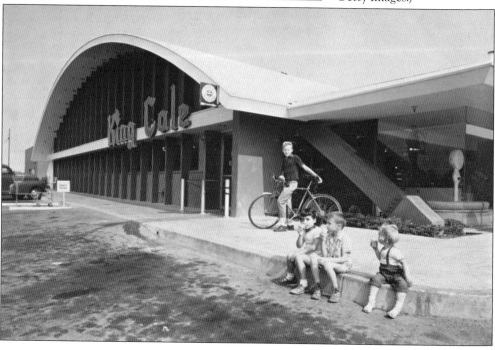

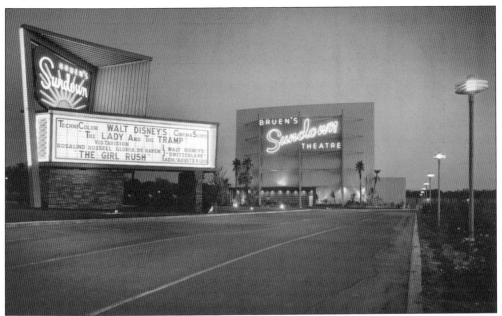

Located at 12322 Washington Boulevard near the intersection with Lambert Road, the Bruen's Sundown Drive-In Theatre opened in 1953. In 1990, the drive-in was closed, and the location operated as a swap meet for several years. The theater was demolished in February 1999 to make way for a shopping center. (WC.)

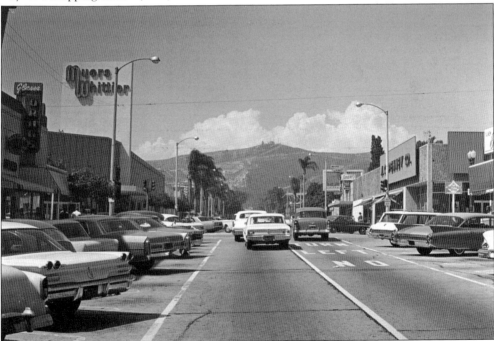

As this c. 1965 photograph of Greenleaf Avenue at the intersection of Bailey Street shows, the city converted Uptown's avenues into one-way streets in an attempt to increase their capacity after World War II. By the 1970s, Greenleaf Avenue had reverted to a two-way street, but Washington, Bright, Comstock, and Milton Avenues remained one-way until August 1982. (WM.)

Whittier's postwar population surge challenged the capacity and services of Murphy Memorial Hospital, built decades before to serve a population one-third the size of Whittier's 1950 population. With help from federal funds (by way of the 1946 Hospital and Survey Construction Act), residents, medical professionals, and the city helped finance the construction of Presbyterian Intercommunity Hospital, which opened on January 11, 1959, on 14 acres of land that was previously part of the Fred C. Nelles Reform School for Juvenile Offenders property. (WM.)

Named after the nearby river, the Rio Hondo Community College District was incorporated in 1960, and classes were held at the newly constructed Sierra and El Rancho High Schools beginning in 1963. Rio Hondo's current campus was built on the former site of the Pellissier Dairy on Workman Mill Road and opened in the fall of 1966 with an enrollment of 6,315 students. In 2014–2015, the college enrolled approximately 20,000 students each semester. (WM.)

Eight

REDEVELOPMENT, REMEMBRANCE, RESILIENCE
1967–1987

The years leading up to Whittier's centennial represent another distinct chapter in the city's history. While expansion and development characterized the 1950s and 1960s, the 1970s and 1980s were years of redevelopment that saw residents and business owners restore and remodel historic structures while the city reimagined Uptown as a tree-lined, walkable "village." (WPL.)

Rediscovering the Dream

Revitalization

In Whittier Village, we have rediscovered the founders' dream. But our confidence in the future is not based on nostalgia, it's based on a sound idea whose time has come again. In Whittier, the founders' commitment to quality of life remains as valid today as when the city was born. And the dream of building an ideal place to live and work is being pursued with renewed vigor.

In a 1977 effort to bring business back to Uptown Whittier, the recently formed Whittier Redevelopment Agency worked with San Francisco planners Charles Page and Associates to reenvision the area. Instead of a bustling, auto-centric shopping district, the Village would hearken back to when Whittier was a small town. Elements like sidewalks—shaded by newly planted ficus trees—and redbrick crosswalks and medians were intended to encourage walking and window-shopping. (WM.)

While nearby cities had hilltops razed for new homes, Whittier's hills were spared, somewhat ironically, because of oil claims that prevented subdivisions from arising. In the early 1980s, Whittierites took action to defend their hills. Following the passage of an ordinance to prevent ridgeline construction, the Friends of the Whittier Hills grassroots group formed to monitor development and promote the "park plan" that acquired and eventually preserved thousands of acres that would become part of the Puente Hills Preserve. (WPL.)

On October 1, 1987, a magnitude 5.9 earthquake hit Whittier. The Whittier Narrows earthquake was the most severe earthquake to hit Los Angeles in two decades, and the effects upon buildings and homes were devastating. Whittier sustained $100 million worth of damage as a result of the temblor and the 5.3 aftershock that occurred three days later. Thousands of residents were displaced, and 17 historic homes and 12 commercial buildings were destroyed. (WM.)

The Whittier Narrows earthquake garnered national attention. Once renowned as the "Quaker City"—a nickname adopted by this Whittier bank that, ironically, had its terminal "R" shaken off in the temblor—after 1987 many people came to associate Whittier with this formidable event that forever altered the city's landscape. One positive consequence was the formation of the Whittier Conservancy, a nonprofit watchdog group dedicated to preserving the city's historic structures. (WM.)

Although the 1987 quake destroyed dozens of historic structures, many longtime residents and new arrivals alike recognized that Whittier's distinctiveness was not something found solely in the city's old buildings. At centennial celebrations held earlier that year (below), and via tokens and souvenirs like the commemorative belt buckle above, Whittierites commemorated the people, friends, traditions, and shared experiences that helped drive the city's progress and shape its character. (Above, Brad and Jennifer Johnson; below, Liz Trueblood.)

When sculptor Christoph Rittershausen proposed a John Greenleaf Whittier sculpture for Central Park, the city was perplexed: no public art yet existed in Whittier, so there were no guidelines about how to proceed. Eventually, officials passed a public art ordinance that allowed for Rittershausen's creation, but the city provided no funding. Instead, Whittier citizens underwrote its $30,000 cost, and the statue was dedicated on Founders Day—May 9, 1987—and remains a beloved Whittier landmark. (Liz Trueblood.)

Discover Thousands of Local History Books
Featuring Millions of Vintage Images

Arcadia Publishing, the leading local history publisher in the United States, is committed to making history accessible and meaningful through publishing books that celebrate and preserve the heritage of America's people and places.

Find more books like this at
www.arcadiapublishing.com

Search for your hometown history, your old stomping grounds, and even your favorite sports team.

Consistent with our mission to preserve history on a local level, this book was printed in South Carolina on American-made paper and manufactured entirely in the United States. Products carrying the accredited Forest Stewardship Council (FSC) label are printed on 100 percent FSC-certified paper.

MADE IN THE

USA